Focus On
Photoshop Elements

The *Focus On* Series

Photography is all about the end result – your photo. The *Focus On* series offers books with essential information so you can get the best photos without spending thousands of hours learning techniques or software skills. Each book focuses on a specific area of knowledge within photography, cutting through the often confusing waffle of photographic jargon to show you simply what you need to do to capture beautiful and dynamic shots every time you pick up your camera.

Titles in the *Focus On* series:

Focus On
Photoshop Elements

David Asch

AMSTERDAM • BOSTON • HEIDELBERG • LONDON • NEW YORK • OXFORD • PARIS
SAN DIEGO • SAN FRANCISCO • SINGAPORE • SYDNEY • TOKYO

Focal Press is an imprint of Elsevier

Focal Press is an imprint of Elsevier
30 Corporate Drive, Suite 400, Burlington, MA 01803, USA
The Boulevard, Langford Lane, Kidlington, Oxford, OX5 1GB, UK

Notices
Knowledge and best practice in this field are constantly changing. As new research and experience
broaden our understanding, changes in research methods, professional practices, or medical
treatment may become necessary.

Practitioners and researchers must always rely on their own experience and knowledge in evaluating
and using any information, methods, compounds, or experiments described herein. In using such
information or methods they should be mindful of their own safety and the safety of others, including
parties for whom they have a professional responsibility.

To the fullest extent of the law, neither the Publisher nor the authors, contributors, or editors, assume
any liability for any injury and/or damage to persons or property as a matter of products liability,
negligence or otherwise, or from any use or operation of any methods, products, instructions, or
ideas contained in the material herein.

Library of Congress Cataloging-in-Publication Data
Application submitted

British Library Cataloguing-in-Publication Data
A catalogue record for this book is available from the British Library.

ISBN: 978-0-240-81445-2

For information on all Focal Press publications
visit our website at www.elsevierdirect.com

Printed in China

11 12 13 14 15 5 4 3 2 1

Typeset by: diacriTech, Chennai, India

Dedication

This book is dedicated to all those photographers out there who want to make their good pictures into great pictures, but who also want to spend as little time and effort as possible in front of the computer in order to get out there shooting their next batch!

About the Author

I'm a keen photographer and a digital artist specializing in Photoshop and Photoshop Elements. I live on the south coast of England, in (sometimes) sunny Brighton, where many of the images I have used in this book were taken.

I believe that although great photos can be made straight from the camera, sometimes they require a little extra help. There should be no taboos about this; it's the final image that counts, after all, and it really shouldn't matter how you get there.

Acknowledgments

A big thank you to my family and friends for their help, their support, and most importantly their patience and understanding whilst I wrote this book.

Introduction

Digital cameras have given people the ability to be carefree with their photography. There's now no need to worry about spending a fortune on film and processing fees – you can shoot to your heart's content and be concerned only about running out of space on your memory cards. This means, of course, that you might come back with several hundred images stored away. Not all of these are going to be perfect; some may be destined for the recycle bin without a second thought, and others could be winners with a just a little bit of tweaking here and there.

The problem is that with this huge amount of photos, it's easy to lose yourself in front of the computer and see the hours fly past as you work to perfect the images. All this lost time should be spent capturing your favorite subjects and exploring new ones, not banging your head against the keyboard in frustration as you try to figure out how to get the colors just so, or how to remove that annoying telegraph pole and its cables from the otherwise picturesque landscape you shot on your last vacation.

The aim of this book is to provide you with quick and easy methods to get the most from your images and improve your workflow, without having to learn every feature and function of Adobe Photoshop Elements unnecessarily. The techniques are written in jargon-free, bite-size steps, which allow you to fly through the editing process with as little effort as possible to get your photos in tip-top shape.

This book covers everything you'll need to make the most of Photoshop Elements, including importing the images from your camera and into the Organizer catalog; sorting, rating, and keywording the images for quick reference; fixing and enhancing your images; and finally, printing and sharing them with your family and friends.

Contents

Contents

Chapter 1: Introducing the Organizer

PHOTOSHOP ELEMENTS IS really two applications: there is the Organizer, where you create and manage your image catalog, and the Editor, where you'll be performing most of your fixes and enhancements. Although they don't have to be used in conjunction with one another, there are many features they share to make your workflow as quick and simple as possible. In this chapter, we'll be looking at the basics of the Organizer and how to import your photos into its catalog.

Key points in this chapter

Exploring the Organizer workspace

Importing photos into the catalog from the camera and other sources

Basic photo management

The Organizer workspace

When launching the Organizer for the first time, you are presented with its workspace. This will be empty at this point, of course, as we have not yet added any photos to the catalog.

We'll begin with a tour of the main areas. The media browser (1) is where your image catalog will be displayed. You can control how the photos appear using the toolbar at the top (2). Here you can increase or decrease their display size from the smallest grid view to a single-image preview.

You can also change the photo's orientation, change the sort order, and perform searches. The panels on the right are where you manage your photo Albums (3) and Image Tags (4).

We'll be exploring all these features in depth later on in the book.

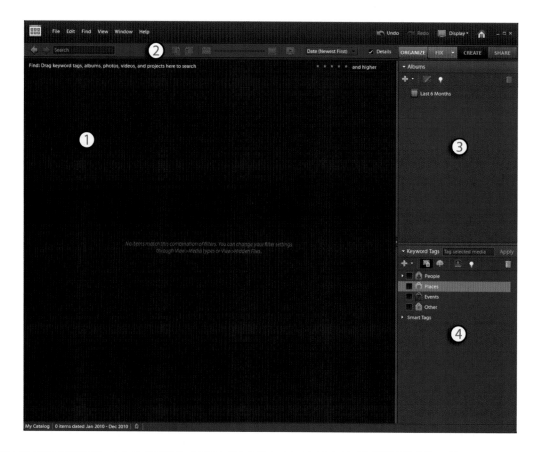

Importing your images from a camera or card reader

Before you can start doing anything with your images, you need to get them off the camera and into Elements. There are several ways to do this, the easiest being directly from the camera, cell phone, or memory card reader via the Adobe Photo Downloader (APD) within the Organizer itself.

Go to the File menu, select Get Photos and Videos > From Camera or Card Reader.

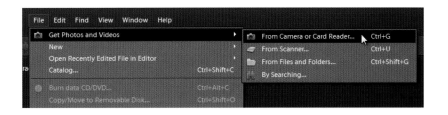

The standard Photo Downloader interface will open. From here you can select the source location of your images, the destination folder, and whether you want to rename the files as they are imported. Clicking the Get Photos button will begin the import.

1. **Source:** The drop-down list will display your camera and card readers. When you select one, it will be read and the images will be displayed in the main window.

2. **Main Window:** All the images from the selected device are displayed here. Each image has a checkbox that tells Elements to either include or ignore the photo when you start the import.

3. **Image Rotation:** Clicking an image selects it; at the bottom of the window are buttons to rotate the selected image clockwise or counterclockwise. It will be in the correct orientation when it's imported.

4. **Save Options:** Here you can specify where the images are stored on your computer. The default location is generally My Pictures. You can create subfolders that can be based on the current date, the date the image was shot, or a custom name. There is the option not to create a folder at all, but that could become a little messy over time! You can opt to change the filename, too. You might, for example, want to change them all to the place they were taken on vacation. Simply choose Custom Name and the starting sequence number.

5. **Advanced options:** There are several automated tasks here (depending on the version you are using) such as automatically fixing red-eye as the images are imported or creating stacks of similar images based on content or date. You can also add the images into a new or existing album within Organizer.

Renaming files is final, so make sure that you really want to change them. In more recent versions of Elements, there is an option to save the original name in the photo's metadata. Check the box Preserve Current Filename in XMP.

6. **Apply Metadata:** Here you can set the photographer's name and copyright information for the images.

7. **Automatic Download:** Both the standard and advanced dialog windows offer the option to automatically import images as soon as the camera or card reader is connected. The current settings are retained and applied the next time. They can be amended at any time via the Preferences menu in the Organizer.

8. **Get Photos:** Once you've made your import choices, it's time to bring them into the Organizer. Click this to start the process.

Copying - 67% Completed

From: **E:\<CASIOEXILIM>**

To: C:\Users\David\Pictures\2005 02 05

67%

File 37 of 53: Copying File...

CIMG0635.jpg

Minimize Stop

The file copy dialog will appear, showing the progress of the file copy. If there are a lot of files being imported, you can hide the dialog by clicking the Minimize button. You can also abort the import by clicking Stop.

Files Successfully Copied

Files have been successfully copied from device, and are ready for import. Elements Organizer will now import these files into catalog.

When finished, do you want to show only the new files in Media Browser?

☐ Always Take This Action

Yes No

When all the images have been copied across, a notification window will appear prior to adding them to the catalog. Here you have the option to display only the files you are importing. This is a useful feature when you already have a large amount of images in the catalog. You can choose to do this automatically each time by clicking the Always Take This Action checkbox.

The import dialog will pop up to show the progress. Any images that were marked for rotation will be done at this stage.

The Advanced Photo Downloader dialog

If you want more control over what is imported, you can switch to the advanced mode by clicking the Advanced Dialog button at the bottom of the Photo Downloader dialog.

Leave the postimport setting to After Copying, Do Not Delete Originals. Ensure that the images are safely in the Organizer first, then remove them from the camera.

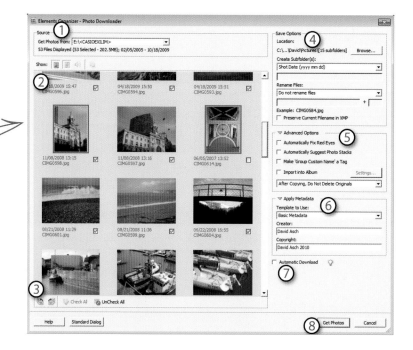

Basic photo management

With the images imported into the Organizer, you can begin sorting through them. The first thing you'll probably want to do is weed out the ones you definitely don't want to keep. One of the quickest ways to do this is to go through and categorize them using the star rating system. You could, for example, mark those that are perfect and need no further editing as a five star, those with potential but require some work with three stars, and the ones that are destined for the trash with one star.

1

To view the images properly, you may want to increase the size of their thumbnails. Use the slider control in the toolbar to increase the size gradually by dragging the slider to the right, or jump straight to the maximum-size preview by clicking the icon on the right.

If you find images that still need rotating, you can click rotation buttons next to the size slider in the toolbar to correct them.

2

In maximum preview mode, you can click the arrows at the top and bottom of the scrollbar on the right to flip through each image or scroll through them by clicking and dragging the scroll handle. You can also use the cursor keys: the right or down arrows move forward through the images, the left and up go backward.

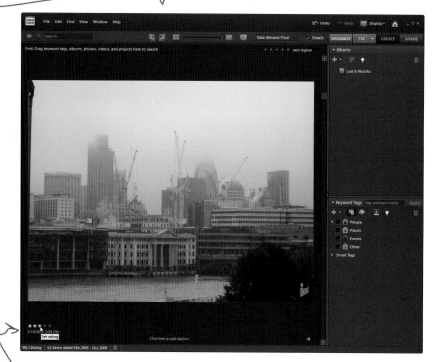

To set the rating, click the appropriate star in the bottom left of the window or press the appropriate number key on the keyboard.

Once you have set the ratings, you can isolate the one-star images using the rating filter. Set the view to small thumbnails by dragging the size slider to the left. Now click the first star in the filter and select **only** from the drop-down list.

Now you can select all the displayed images all by choosing Edit > Select All. When you're sure you want to continue, delete them by selecting Edit > Delete Selected Items From Catalog or by pressing Del on the keyboard.

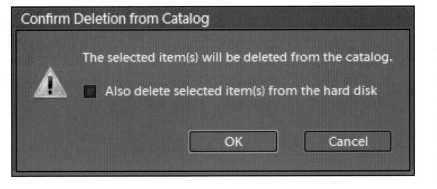

A warning message will appear asking whether you want to delete the items from the hard disk as well. If you check this box, the files themselves will be permanently deleted from the computer; otherwise, they will just be removed from the Organizer's database and can be reimported if you change your mind; they will, however, continue to take up space on the hard drive.

Click the Show All button to clear the filter and display the full catalog once more. This will now contain only your three- and five-star images.

Importing from other sources

As well as adding images from your camera, you can also add photos to the catalog from existing folders on the hard drive or archive CDs or DVDs.

1

From the File menu select Get Photos and Videos > From Files and Folders. A file browser dialog will appear. From here you can elect to import an entire folder, or batch of folders, with the option of including subfolders or one or more individual photos. Once you've made your selection, click the Get Media button and the photos will be added to the Organizer catalog.

When you add photos in this way, the files remain in their original location, unless they are imported from CD or DVD, in which case they will be copied onto the hard disk, as the disc may not always be in the drive.

Automating your imports

As well as the manual method of adding photos to the catalog, the Organizer can be set to automatically import files from designated locations on the hard disk, known as *watched folders*. Tell the Organizer which folders to monitor and it will automatically detect newly added files and import them, either notifying you first or adding them transparently in the background.

1

Go to File > Watch folders. A dialog will appear. Make sure Watch Folders and their Sub-Folders for New Files is checked. Click the Add button and navigate to the folder you want to watch in the file dialog. You can add as many as you like in this way. Click the desired action for when new files are found: the program can either notify you first or automatically import them in the background.

Watch Folders

☑ Watch Folders and their Sub-Folders for New Files

Folders to Watch

C:\Users\David\Pictures\

Add...

Remove

When New Files are Found in Watched Folders

○ Notify Me

◉ Automatically Add Files to Organizer

OK Cancel

Chapter 2: Tagging, Sorting, and Searching

THE MORE PHOTOS you add to the Organizer, the more difficult and time-consuming it will become to keep track of them. You can sort them by date and other simple criteria, of course, but that applies only to the entire catalog: tricky if you want to pick out that small set of photos from the lovely day trip you had some time ago in the last five years, amid the thousands of pictures you have amassed since!

Fortunately, Elements has the answer. Aside from simply importing your images into the Organizer, you can sort them into *albums* (sometimes referred to as *collections*) and assign keywords to the photos themselves, allowing you to refine searches to specific objects, people, and places – or however else you decide to categorize them.

In this chapter, we'll look at the methods of organizing your photos and the ways this can benefit your workflow as the size of your catalog expands.

Key points in this chapter

The purpose of tags and categories: how and why they are used

Deciding how you want to categorize your photos and adding the keywords

Using keywords and categories as filters and in searches to speed up your workflow

Creating and working with albums

The purpose of categories and tags

Imagine your photo catalog is a department store. Your photos are the individual products available within that store. Without a good store plan and a list of the sections within the departments, it would take hours to find the item or items you wanted to buy. The Organizer uses tags and categories in much the same way to allow you to fine-tune the cataloging process for your photos, making it much quicker and easier to locate particular photos or sets of photos from the potential thousands you have stored on the computer.

Each of your photos can belong to several categories and subcategories and can also be assigned many individual tags. All this might sound a bit daunting to begin with, especially if you already have a lot of photos that require categorizing, but once you have built up a comprehensive set of tags and categories, it quickly becomes part of the cataloging workflow.

Creating and using a tagging structure

The rules for creating the structure of your tagging system are by no means set in stone; different people use varied criteria, but there are guides to help you out in the beginning. Elements gives you a default set of categories to get you started that covers the most likely types of photos you can add: People, Places, Events, and Other. For the purposes of this chapter, we can start our tagging with these basics and add more refinements later.

1

Looking through the catalog, there's a large batch of car photos. These were taken at a London automobile show, so we have two definite categories already: Places and Events. Obviously, we don't want to add the tags to each photo individually, so we'll multiselect them. We click the first image in the set, hold down the Shift key, and click the last in the set. All the images between them will be selected.

2

We'll start by adding these photos to the Events category. Click on the Events tag in the Keyword Tags panel. Holding the mouse button, drag it across to the catalog window. The cursor will change to a hand holding the tag icon as you hover over the thumbnails. To apply it, release the mouse button. The icon will appear briefly on each thumbnail to show it's been added.

You can see how tags work immediately. Clicking the checkbox to the left of the Events category reveals the binoculars icon. The only images now showing in the catalog window are those tagged as Events. There is also a red tag next to each thumbnail. While the images are filtered, we can select them all (choose Edit > Select All) and add the Places tag by dragging it across as we did before.

If you can't see individual tags, increase the size of the image thumbnails.

▶ Albums

▼ Keyword Tags `Tag selected media` Apply

+ ▾ | 🗂 | 🌂 | 👤 | 💡 | 🗑

 ✚ New Keyword Tag... Ctrl+N
 New Sub-Category...
 New Category...

 📝 Edit...

 From File...
 Save Keyword Tags to File...

 Collapse All Keyword Tags
 Expand All Keyword Tags

⊞ Create Sub-Category ✕

Sub-Category Name

London

Parent Category or Sub-Category

Places ▼

OK Cancel

Having added our two base categories, we can refine them a stage further. With the Places category still highlighted, click the green plus icon at the top of the panel. Select New Sub-Category from the menu. The Create Sub-Category dialog will appear. We've entered *London* here in the Sub-Category Name box. We can now add this tag to the images as well.

⊞ Create Category ✕

Choose Color...

Category Name

Cars

Category Icon

👤 🏛 📅 ✳ ⚡ 🕊 📦 🏘

OK Cancel

We can also add new base categories to the list. As the photos in the current batch are probably all cars, we'll create a new category called *Cars*. Click the green plus icon again. This time, select New Category. Here we can choose the tag's name, color, and icon. Name it *Cars* and give it the lightning bolt icon. Make sure all the car photos are selected and apply the new tag as before.

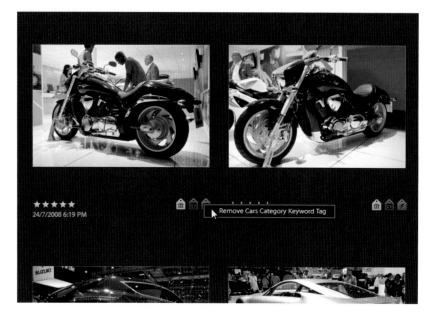

6

Looking through the images we just tagged, we've noticed that they are not all actually cars. There are a couple of photos of motorcycles as well. Right-clicking on the Cars tag beneath the thumbnail gives us the option to remove it from the photo. We'll do this for each one. If you are viewing smaller thumbnails where the individual tags aren't visible, you can right-click the thumbnail and select Remove Keyword Tag from the menu.

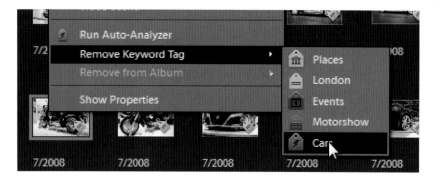

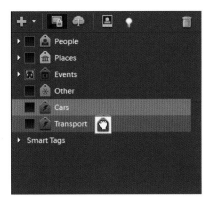

7

The previous step highlights an issue. We need another tag for motorcycles, but it will become untidy if we start adding new types at the top level. Instead, we can create another new base category, Transport. We can click and drag the Cars tag on to the Transport tag, which converts it to a subcategory. We can also create the Motorcycle subcategory as a child of the Transport tag and apply it to the bikes.

We need to add the car and bike photos to the new Transport category as well!

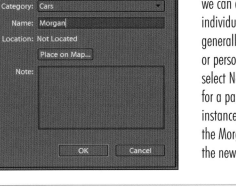

8

To tighten the cataloging process further, we can add more specific tags to describe individual photos. These labels are generally the actual name of the object or person. Click the green plus icon and select New Keyword Tag. We'll create a tag for a particular car manufacturer – in this instance, it's Morgan. Now we can select all the Morgan cars in the catalog and apply the new tag.

MAKING TAGS PERMANENT

When tags and captions are added to an image, they are referenced only from the Organizer's database. If you export the files or copy them directly from their folders to another location, the information will not be retained.

To make sure they are attached to the image file itself, either open the image in the Editor and save it, or select the images you want to add the tags to and go to File > Write Keyword Tag and Properties Info to Photos. Now you will see the information when you open them with another piece of software, or on another computer. The information may also be picked up by online photo galleries such as Flickr.com and will be added accordingly.

Filtering and searching your catalog

You've already seen how easy it is to narrow down groups of photos using a particular category or tag as a filter. In this section, we'll look at the many ways of sifting through your photos using Elements' many search features.

As well as using the tagging system, we can use other information, including the photo's EXIF data, if it's present, so we can isolate images based on all kinds of criteria, such as the camera they were taken with or the orientation they were shot in. There is also a history feature that stores details of when the photos were imported and the date of the last modification. These can all be combined to provide an incredibly powerful way to isolate your images.

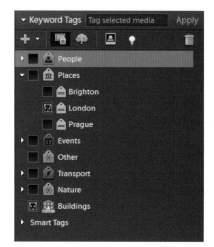

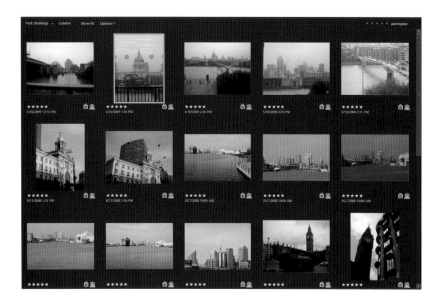

You can combine two or more tags or categories in your search to display photos that only have certain traits in common. Here, for example, we've clicked the filter checkbox against both the London subcategory in Places and the Buildings category. This is telling the organizer to show us only the photos of buildings taken in London. We can see the binoculars symbol against both tags.

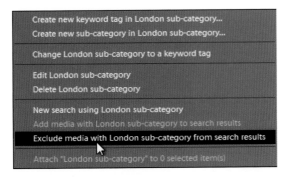

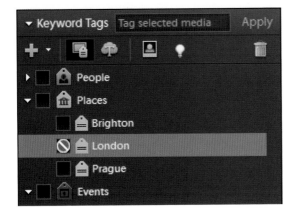

2

We may also want to exclude a particular tag or category from the search. Using London as an example again, right-clicking on its category brings up the contextual menu. Here we can elect to exclude all instances of this tag and display only buildings that are *not* labeled as being in London. This time, instead of the binoculars symbol, we instead get an exclusion symbol next to the London tag, denoting that it's hidden.

USING THE EXCLUDE FEATURE TO FIND UNCATEGORIZED IMAGES

We can also use the exclude media feature to discover photos we may have missed in the initial tagging process. We might, for example, have a tag for butterflies. If we view the entire catalog but exclude all images with the Butterfly tag, we can scroll through the thumbnails and quickly spot any that have not been tagged, as they will still be displayed.

It's worth noting, however, that the filter is not live, the thumbnails won't be removed from view after they have been tagged; you'll need to reapply the exclusion filter to make sure you found them all.

Searching the catalog

The Find menu offers us a wealth of options, the most powerful being the Find by Details dialog. Although it might look a little daunting at first, it's surprisingly easy to follow. We can specify up to ten different rules for searching the catalog. These can be anything from the rating to the focal length of the lens when you took the photo. The method in which the rules interact is what's known as Boolean, meaning that the file data can either match any of the specified search criteria to be included (OR), or must match all of it (AND).

In the following example, we'll create a search pattern that will show us only the photos relating to transport in the catalog that were taken in the last year using a Canon camera in portrait orientation.

When you open the dialog box, if you haven't used it before, it will be set to its default values. To begin with, we need to make sure the search matching is set to *All of the following search criteria [AND]*. If we don't do this, it will simply show any photo with one of the specified traits. We might want to use that kind of search in some instances, but it's far too broad for this purpose.

Find by Details (Metadata)

Search for all files that match the criteria entered below and save them as Smart Album. Smart Albums are albums that automatically collect files that match the criteria defined below. Use the Add button to enter additional criteria, and the Minus button to remove criteria.

Search Criteria

Search for files which match: ○ Any one of the following search criteria[OR]

○ All of the following search criteria[AND]

| Capture Date | ▼ | Is within the last | ▼ | 12 | ⬍ | Months | ▼ | | + |

The date when the photo was taken

■ Save this Search Criteria as Smart Album

Name:

Search Cancel

There's no need to use a particular order for the rules; they are treated as a whole when applied.

2

Clicking the first drop-down gives us all the possible search fields. We'll start by setting the *Capture Date*. When we do this, the subsequent detail fields change to reflect the choice. Next, we'll choose the option *Is within the last*, which lets us set our time period back from the present day. Finally we'll set the number to 12 and the period to *Months* to give us a span of a year.

Next we'll define the tags to search. Start by clicking the plus button to the right of the previous search fields; this adds a new rule picker. Select *Keyword Tags* from the drop-down list. *Include* is automatically put in as the second option. The third option presents us with the entire list of categories and tags available. We'll select the main *Transport* category to ensure that all instances are included.

Click the plus button again to add a new search field. We'll choose *Camera Make* from the list. The next field gives us two options: *Contains* or *Does Not Contain.* We'll be using *Contains,* as we want to display all the photos that were shot with our specified camera. The last field is free text: type in *Canon* for the make.

5

The final part of our example search is to pick only photos that were shot in portrait orientation. Click the plus button once more to add another field. This time select *Orientation* as the criterion and choose *Portrait* as the type. Click the Search button at the bottom of the dialog to continue. The time it takes to complete depends on the size of the catalog, but it shouldn't take too long.

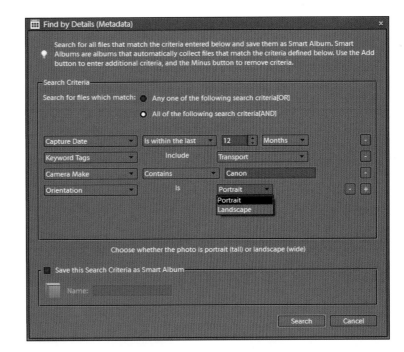

The figure on the lower right shows the results of our search. In this case, only four images matched all the criteria. We can click the Options menu in the top-left corner of the window and choose to save the results as a Smart Album (more on these later in this chapter) or modify the search criteria to add, remove, or alter the search fields.

There are two more options: *Hide best match results* and *Show results that do not match*. The first is generally used with Elements' automated comparison features, which gauge similarities in photos and score them; if we use it here, it just hides the results completely. The second simply reverses the results, showing only the photos that did not meet our search terms.

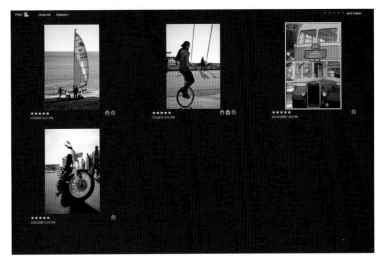

Creating albums

Now that we've created our tags and categories, it's much easier to refine the view to only certain photos or sets of photos. We also have the facility to place groups of photos in albums. There are two types: Standard, and in later versions, Smart Albums. The concept of tags and albums may seem to be the same, as both enable you to filter your images in the catalog; albums, however, are much better for when you have a specific purpose or project you want to work on.

Vacations are a good example of when you might favor albums over standard categories or tags. You would want to categorize all the photos you took while on vacation, but may not want to print them all. Instead, you can create a new album called, for instance, Best Vacation Shots. You could first use a combination of tags and ratings to select the images you want, and then place them inside the album, effectively saving your search results. You can also place the photos in any order; this is especially useful if you are planning on creating a book or slideshow.

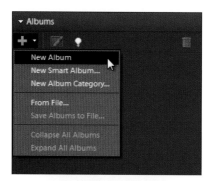

To create an album, click the green plus symbol at the top of the Albums panel. Select New Album from the menu. The panel will change to show the Album Details dialog. Here we can specify the name of the album — *Vacation Best*, in this instance. We can also select a category if required. There is the option to start adding photos, but we'll skip this for the moment. Click Done to continue.

If photos had been selected when we created the album, they would have been automatically added to the album.

2

We can start adding photos to the new album. Using the image tags, we've filtered out all our vacation photos. We've also used the ratings system to show only five-star images. Now select the whole batch (Edit > Select All) and either drag them over onto the album in the Album panel or drag the icon onto the photos. The Album icon will appear alongside the other tags under the image.

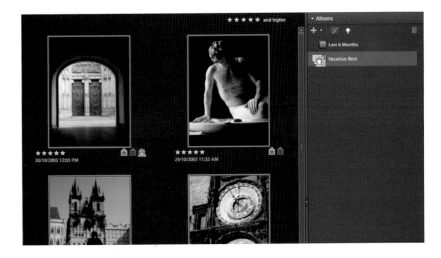

3

When the album is selected, the images within all have a number in the top-left corner. This denotes the order in which they will be placed into a slideshow or exported to the Editor to create photo books or collages. To change the order, simply click and drag the photos around the workspace and place them in the desired position. The new sequence will be saved and displayed each time the album is viewed.

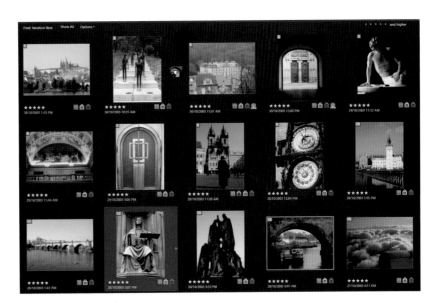

If you decide that you don't want an image in the album after all, it can be removed by either right-clicking the album icon under the photo and selecting Remove from (album name) Album or right-clicking the photo itself to display the menu and selecting Remove from album > Album name. This won't delete the photo itself, of course!

Album categories

If you find that your individual albums are becoming too cluttered, you can create categories. This could be compared to a shelf where the albums sit; in our vacation example, you could create a category named *Vacation Best*, and inside this category you could create several albums based on the individual places you have visited, each with their own select set of photos.

You can also create subcategories within categories!

To create a category, click the green plus symbol and select New Album Category from the menu. Call it *Vacation Best* and click OK. We get a warning message here, as the category name is the same as our album name, which could become confusing if we have many albums and categories already set up. We'll be changing the name of the album anyway, so click OK to proceed.

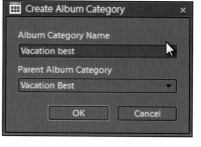

2

Select the album by clicking its entry in the Albums panel. Now click the Edit icon at the top of the panel (a square with a pencil in front). This takes us back to the album information dialog. Click the category drop-down and choose the *Vacation Best* category. Now change the album name to *Prague 2003*. Click Done to set the changes. The album now appears as a subset of the category.

To speed up your workflow, you can also drag and drop albums into subcategories to add them.

If you want to remove an album from a category, however, you would need to edit the album's properties and set it to None - top level.

Creating Smart Albums

In more recent versions of Elements (versions 6 and later), you can create Smart Albums. These are similar to regular albums, but their content is not created manually by dragging and dropping photos; instead, they use metadata to automatically include images matching the criteria. Essentially, they are saved searches that update dynamically; whenever you add a tag that matches or any other trigger, such as its rating, it will be included in the Smart Album. This type of album is most useful for sets of photos that will grow over time, rather than one-off events.

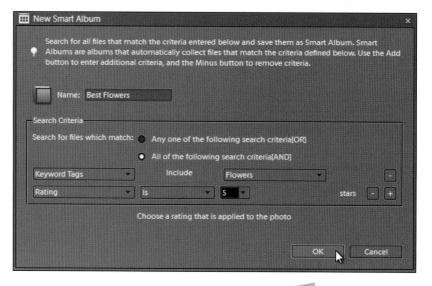

1

Similar to creating regular albums, to create a Smart Album, go to the green plus icon and choose Create Smart Album from the menu. A dialog will appear that looks very similar to the Find dialog we worked with earlier in the chapter. First, we're prompted for a name; call it *Best Flowers*. Next, we're asked for our criteria. We've set it to show all images tagged as Flowers that also have a five-star rating.

You can also create Smart Albums from the Find dialog itself. Check the box at the bottom labeled Save Search Criteria as Smart Album. This can also be done when using tag filters by selecting the same option from the Options menu in the main window.

2

Here are the contents of the new album: all are flowers and all have a five-star rating. The difference between this and a regular search is that it continuously updates. If we were to remove the *Flowers* tag on one image or drop the rating on another, the next time we accessed the album, they would no longer show up. Similarly, if we add new photos with the *Flowers* tag and they are given a five-star rating, they would also be included.

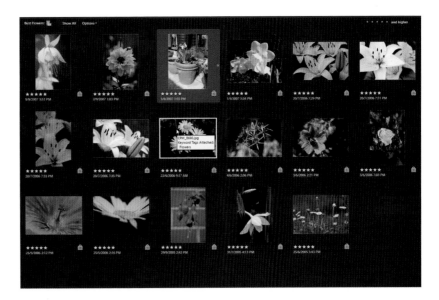

NOTES ABOUT SMART ALBUMS

• Images in a Smart Album aren't tagged with the album name as they are with regular albums.

• Regular albums and album categories can also be included as part of the search criteria. This is set using the Album > Include search field.

• Unlike regular albums, you cannot change the order in which the photos appear. You can, of course, create a regular album from the results, but it would no longer be live.

• You cannot edit the criteria of the search – only the album name. If you want to amend or add different search results, you would have to create a new album.

There are, of course, almost infinite ways to search and filter your photos. The key to it all is to maintain a routine of tagging your photos as you add them to the catalog – even if it's just adding a single word to begin with, if time is an issue. At least it gives you a starting point and can save you hours in the long term. Once you have a comprehensive library of tags, it becomes much easier to apply them as you go.

Chapter 3: Working with the Editor

OCCASIONALLY, WHEN WE look through a batch of photos, there will be some perfect five-star shots that hold their own straight from the camera, without having to do anything more to them. This doesn't mean that all the rest should be cast off as hopeless, of course. All those images with crooked horizons, lackluster colors, over- and underexposure, poor lighting, and so many other ailments need not end up in the trash.

In this chapter, we'll look at some of the common problems you may encounter with your photos and how to fix them using the second and most important part of the Elements package, the Editor. Using its comprehensive collection of adjustments, tools, and filters, we'll demonstrate how to bring your photos back to life with the minimum of fuss and effort – often with nothing more than a single mouse click!

Key points in this chapter

Exploring the Editor's workspace

Bringing images into the Editor for adjustment

Making sure your images are of good enough quality by checking for sharpness

Straightening, cropping, and fixing lens distortion

Light and color correction

Retouching and removing distractions from the photo

Image noise reduction and sharpening

Opening images in the Editor

Before we start doing any work, we need to get the images into the Editor. There are several ways of doing this:

1. Via the Organizer: This can be done either from the main menu or by right-clicking the photo's thumbnail and selecting Edit > Edit with Photoshop Elements.

2. From directly within the Editor: Go to File > Open and choose the relevant image from the file open dialog.

3. You can also open the image from your operating system, such as in Windows Explorer. When you install Elements, it associates itself with image file types, so as long as you haven't altered this, when you double-click an image, it will open inside Elements.

The Editor's workspace modes

The more recent versions of the Editor (versions 6 and later) have three edit modes: Full, Quick, and Guided Edit; earlier versions have only Full and Quick. Full Edit is the most comprehensive of them all, giving you all the tools and functions available. Quick Edit concentrates on the features you would be more likely to need on a regular basis when editing your images, removing the more specialized tools for a clearer workflow. Guided Edit helps you through specific editing tasks step by step, acting as a bridge between the Quick and Full Edit modes. You can switch between the different modes at any time, which gives you great flexibility in your workflow.

For the purpose of maximum compatibility with all versions, we'll be concentrating on the Full Edit mode for the techniques in this chapter, but will look at the other modes for reference purposes.

If your images are RAW files, they will open with Adobe Camera Raw rather than directly into the Editor. Refer to the next chapter to find out more about the Raw workflow.

The Full Edit interface. This is the initial edit mode when you launch the Editor.

1. **The workspace:** This is where all the editing work on your images is carried out. You can have one image window open at a time or several. The windows can be arranged manually or automatically within the space.

2. **The toolbox:** This contains all the Hands-On tools for cropping, making selections, retouching, text, and so on. Other functions are held in the various menus at the top of the screen.

3. **The Options toolbar:** This changes to show the various options available for the currently selected tool.

4. **The workspace modes:** These are the menus for switching between the edit modes and also for accessing the Create and Share project options.

5. **The panel sidebar:** This contains the various panels used in the editing process, such as Layers, Effects, Histogram, and so on. These can be added and removed to suit your need. Panels can also be dragged out as floating windows in the main workspace.

6. **The Project Bin:** This displays thumbnails of all the currently open images. It is also used when putting together albums, slideshows, and other creative projects.

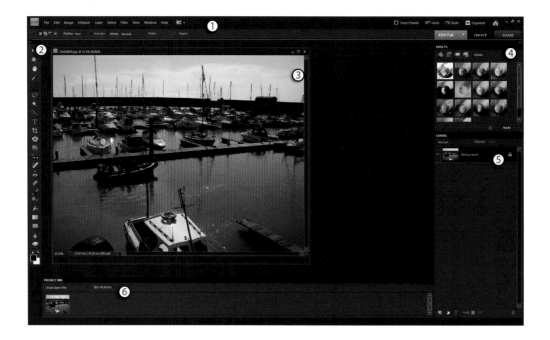

The Quick Edit interface. This is selected from the Edit Modes menu at the far end of the options bar.

1. The workspace and viewing modes: This differs from that of the Full Edit version, as the photo you are working on is fixed to the background of the workspace, and cannot be viewed in a floating window. The View popup menu allows you to display the image in several ways, either as a single before (the original photo) or after image (the result of the corrections you have made), or a combination of the two in horizontal or vertical aspects.

2. The toolbox: As you can see, this is a much more basic version as compared to Full Edit mode.

3. The menus and Options toolbar: You still have full access to the menus and most of their functions within the Quick Edit mode. The Options toolbar, as with the Full Edit mode, gives you control over the current tool.

4. The Quick Fix panel: This contains the most frequently used color and lighting adjustments.

5. The Project Bin: This is the same as in Full Edit mode. You can switch between your currently open images without leaving the Quick Edit interface.

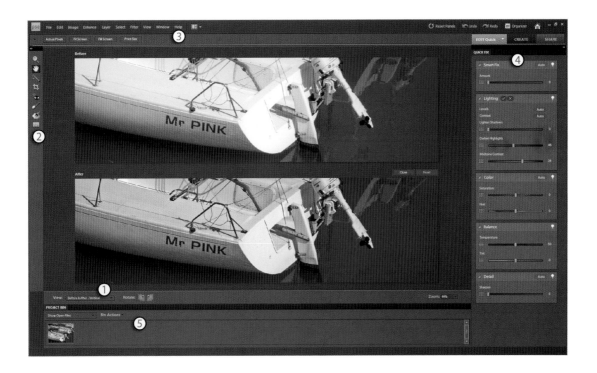

The Guided Edit interface.

1. **The workspace:** This is the same as Quick Edit with its static image and one-up or two-up display mode.

2. **The toolbox:** This is even more cut down than in the Quick Edit version, giving only the Zoom and Hand tools.

3. **The menus and Options toolbar:** In this mode, almost all the menu functions are disabled, apart from file handling and the zoom views. As before, the Options toolbar gives you control over the (limited) tools.

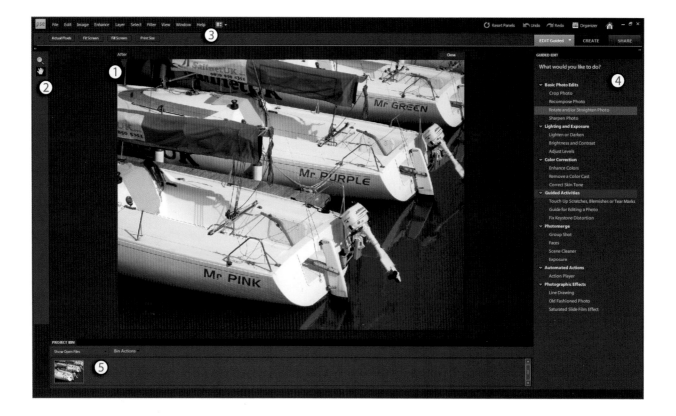

4. The Guided Edit panel: Instead of individual correction tools, the items in this panel contain some of the most common actions you might need to perform on your photos. Clicking each item gives you a brief explanation of how to use the tool and how it affects the photo (see figure below on this page).

5. The Project Bin: Again, as with the Full and Quick Edit modes, this displays all your currently open images and lets you switch between them.

GUIDED EDIT

Lighten or Darken a Photo

Press the Auto button to automatically fix the photo's exposure:

Auto

Use these sliders to manually balance the shadows and bright spots:

Lighten Shadows:

Affects only the dark areas.

0

Darken Highlights:

Affects only the light areas.

0

Midtone Contrast:

Affects only the medium-bright areas.

0

Reset

Initial checking and correction

Although there is no right or wrong sequence to editing your photos, there are a couple of operations that are best performed before any major corrections are made. First, check that the photo is in sharp enough focus. It's possible to apply faux sharpening to make the image clearer, but that won't rescue a completely fuzzy subject. Straighten the image if required; this will result in border areas being cropped away, and if too much is removed, it might affect the composition of the photo. Once these checks and adjustments have been made, you can move on to lighting and color correction, along with any spot editing and retouching that the photo may need.

Checking the sharpness

Remember to switch back to Full Edit mode if you're not already there!

When you view an image in the Organizer or open the image, it will be scaled to fit the screen, which often means you cannot tell whether it's completely in focus. To check the sharpness of the image, we need to view it at 100%. Select View > Actual Pixels. The photo will now display at its full size and we'll be able to see at a glance whether it's crisp enough.

You can also double-click the Zoom tool's icon in the toolbox or press Ctrl+1 to set the view mode to 100%.

2

When viewing at full size, you'll be able to see only a small portion of the image at a time. You can use the scroll bars of the window to move around, but that's a little awkward. Instead, select the Hand tool, either by clicking its icon in the toolbox or by using its keyboard shortcut (H). Now you can click and drag on the photo to move it around inside its window.

You can also hold the spacebar on the keyboard to temporarily access the Hand tool.

You can also use the Zoom tool to enlarge the image, but be careful not to exceed 100%, as this will not give you a true representation of the sharpness. The zoom factor is shown in the bottom-left corner of the image window.

Straightening crooked photos

It's inevitable that some of your photos will end up crooked. Sometimes this is done intentionally, for artistic reasons, but for landscapes, seascapes, and other such shots, a slanting horizon or listing building is the last thing you want. The Straighten tool gives you a quick and easy way to fix these problems.

STRAIGHTEN TOOL OPTIONS

The Straighten tool has three settings that determine how the image is rendered once it has been adjusted; these are set using the Canvas Options menu in the Options toolbar:

- **Grow or shrink canvas to fit (default):** This adds or removes space around the image to square it off, without clipping the image. The empty space is filled with the background color.

- **Crop to remove background:** This is generally the preferred method, as it automatically removes the excess.

- **Crop to original size:** This is similar to the default option but trims away the corners of the image.

1

Here we see that the photo has a heavy slant. After selecting the Straighten tool from the toolbox, click and hold the cursor on the horizon line at the left edge of the image. Now, keeping the mouse button clicked, drag the tool across to the opposite edge. Make sure the cursor is positioned on the horizon before releasing the mouse button and then let go. The image will be rotated.

It helps to stretch the window out slightly so you can clearly see the edges of the photo.

Straightening verticals

You can also use the tool if the image you need to straighten is vertical, such as a building. Start by finding a good vertical object in the image; something close to the center is best, to avoid the adverse effects of lens distortion that can happen toward the edges. Once you have your guide, use the tool in the same way as before but, before you release the mouse, press and hold the Ctrl key. This tells Elements that you're working with a vertical – otherwise, it would rotate it 90 degrees!

Advanced distortion correction

Another common problem for photographers is lens distortion. This is particularly evident when photographing buildings with a wide-angle lens. The image often has a bulged effect, making the straight edges appear curved.

Since version 5, Elements has included the Correct Camera Distortion filter. This incredibly powerful tool not only straightens crooked pictures but also removes bowing distortion as well as horizontal and vertical distortion; this can correct images that have an unwanted converging effect – in which the lines of a building appear to move toward each other, for example.

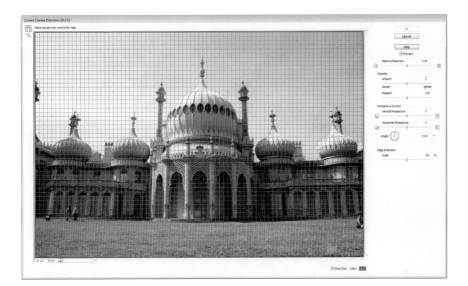

1

Begin by opening the image you want to correct. Go to Filter > Correct Camera Distortion. The filter has its own dialog comprising a sparse toolbox containing only the Zoom and Hand tools, the main image window, and the various controls on the right-hand side. By default, the image is overlaid with a grid to aid with aligning when correcting the photo. The grid can be hidden if it becomes intrusive.

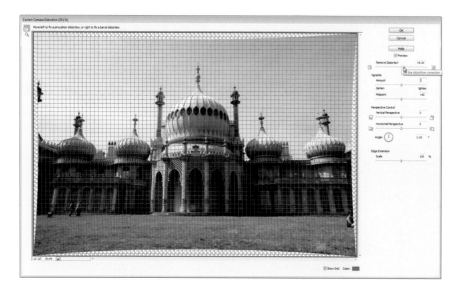

2

The image seems to be fairly straight already, so we'll start by removing the curved distortion. Our image bulges out toward us (convex), so we need to apply a concave adjustment. We do this by dragging the Remove Distortion slider to the right. Look for strong vertical or horizontal lines to act as guides; the steps at the base are perfect. Keep adjusting until the curve is removed: an amount of +9 works well here.

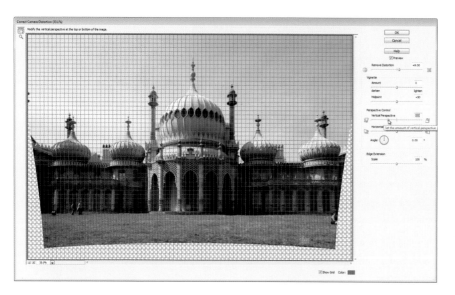

3

We've done a good job of correcting the curved distortion, but we can see that the spires of the building are converging toward the center slightly; we can remove this with the Vertical Perspective Control. The building gets narrower towards the top, so we need to compensate by dragging the slider to the left. We can use the pillars as a guide against the grid lines to get it as straight as possible.

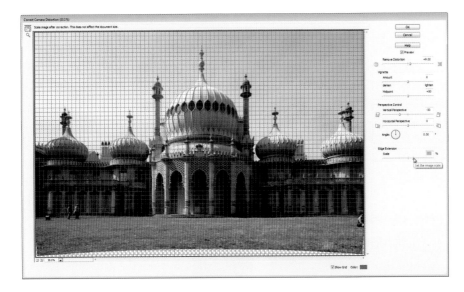

There is a lot of blank space where the image has been transformed. Here we can use the Edge Extension Scale feature. This increases the size of the pixels to fill the screen. We increase it by around 10% before it starts to become noticeable, depending on the original quality of the image. We now have to crop only a small amount away from the bottom but the photo still retains its original dimensions.

As with any image manipulation we need to decide if the image works without alteration or if it would look better edited, with the sacrifice of a small amount of its original quality. Often the changes will be unnoticeable.

Cropping your image

There are often times where the image needs to be cropped down. This might be to remove a distracting element that's easier to cut from the photo rather than trying to remove it by cloning. It may just be to change or correct the composition. Again, all this is generally something that should be done before any adjustments to the image are made.

The tool itself has several presets that can be chosen to keep the aspect ratio constrained to the most commonly used photo paper sizes. We can also create a freehand crop or specify the exact dimensions by typing them into the width and height boxes.

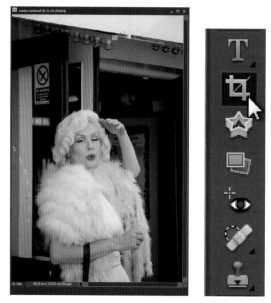

1 This shot of a Marilyn Monroe look-alike was taken in a hurry and as a result is not very well composed. There's a lot of distracting space around her. We'll begin by selecting the Crop tool from the toolbox. We could at this point pick one of the presets but for the purpose of demonstration, we'll use it freehand. We can always change it before we commit to the crop.

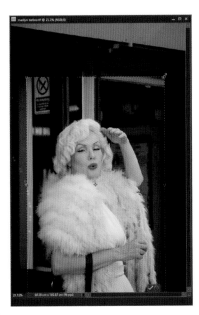

We'll start by creating a loose crop boundary. Position the cursor on the image, then click and drag out the bounding box. There's no need to be too accurate at this point, as we can edit it afterwards. Once you've drawn it, release the mouse button. The boundary stays in place and is surrounded by a darker, semiopaque border to make the crop easier to see against the rest of the image.

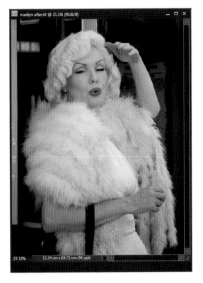

We can fine-tune the crop boundary by clicking and dragging the perimeter handles. The corners size the box diagonally; the middle handles adjust vertically and horizontally. If you want to size the box proportionally, hold the Shift key while dragging the corner handles. You can move the entire box by clicking and dragging inside the boundary. When you have the correct proportions, click the green check mark at the bottom to perform the crop.

Tone and color correction

When you get back from a day out or vacation and look at the photos you have taken, they often seem to lack the vitality of the scene as it looked at the time. The colors might be flat or the subject might be lost in shadow or blown out with glare.

These problems can happen for many reasons: the camera's auto-sensing features picked up on the wrong area of the subject and overcompensated, you may have accidentally left the camera set to a different shooting mode, or maybe it's just that the way we see the world around us differs from how the camera does.

Whatever the reason, we can usually fix these problems quickly in Elements. There are many ways to approach each problem; some can be as simple as a single auto-correction operation, others require a little more time and effort, but the final results will be worth it.

Auto adjustments

Elements has four automatic correction features; it's always worthwhile trying these first. They are quick to apply and usually give good results. Even if they don't do a great job, it can serve as a foundation to work with. If you're not happy with the results, you haven't lost much time and you can always undo the changes and try a different method.

1

This landscape image is nice enough, but it's suffering from being washed out and flat. The sky is hazy and the colors of the tree and the surrounding fields are lacking that all important contrast and punch. For this photo, we'll try the overall adjustment approach, which attempts to correct the color, highlights, and shadows in one operation.

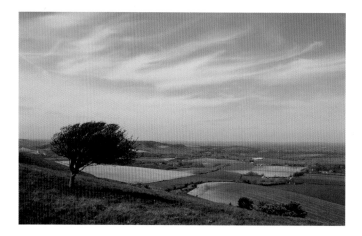

From the Enhance menu, rather than choosing the fully automated Auto Smart Fix, we've selected Adjust Smart Fix. This offers us more control over the adjustments. Begin by clicking the Auto button. This gives the same result that we would see from the completely one-click version. It's done a good job, but we can now adjust the slider to fine-tune the image.

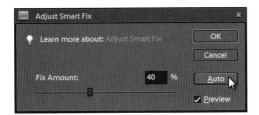

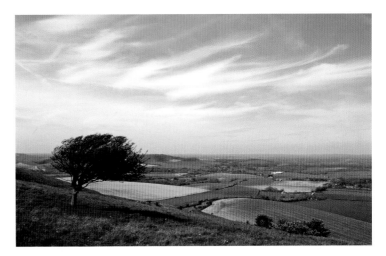

Here we've pushed the effect up to 80%. Although the difference is not immediately obvious, by doing this we have boosted the contrast and color a little more to give the final image more punch.

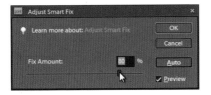

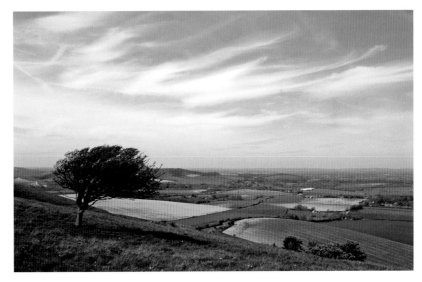

There are three other auto-corrections available, each performing a slightly different function:

• **Auto Levels:** This corrects the overall contrast of the image, affecting each of the color channels. As a result, the colors in the image may be affected.

• **Auto Contrast:** Use this when the contrast is poor but the colors don't need adjusting.

• **Auto Color:** This adjusts the tonal balance of the colors in the image, giving a stronger and more even spread.

Generally, you would use only one of the automatic corrections, as applying several is likely to have a detrimental effect.

Manual corrections

Previously, we used one of Elements' automatic correction functions to fix an image. In this instance, it did an excellent job and no further editing was necessary. This isn't always the case, of course. Very often Elements will be confused by the colors or tones of the image, perhaps assuming that a large expanse of color is a color cast, rather than an integral part of the image. You might also have purposely over- or underexposed the image for effect; you wouldn't want that to be corrected.

With this in mind, we'll explore some of the methods of manually correcting your images. This isn't as laborious as it might sound: fixes of this type can be just as quick as the automatic ones, with the benefit of more control over the results, of course.

Exposure correction

Not getting the correct exposure is a common problem that photographers face. This is often the case with pictures taken with compact cameras in fully automatic mode. The camera will sometimes pick up the wrong area of a scene and overcompensate, either over- or underexposing the image.

All is not lost, however. We can very quickly fix many exposure problems using image layers and blend modes. If we imagine our image to be printed on a piece of clear film, we make a duplicate of this that sits on top of our original. Blend modes change the way the images on each layer interact with one another. In our first example, we'll be using the Screen blend mode to fix an image that's been underexposed. In the second, we'll use Multiply (the exact opposite of Screen) to fix overexposure.

Fixing underexposure

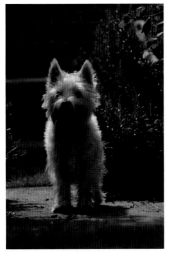

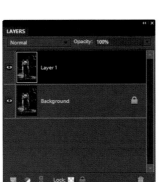

1

Here's our starting image. Although it has an even tone, it has been underexposed. Firstly, we'll make a copy of the image onto a new layer. From the Layers menu select Layer > New > Layer via copy. If you look at the Layers panel, you can see that there is now a copy of the background image named Layer 1. You won't see any difference yet, of course, as we haven't made any changes.

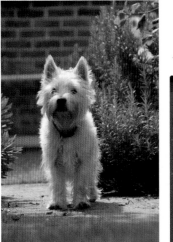

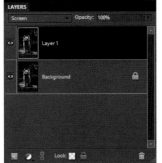

2

At the top of the Layers panel, there's a menu that currently shows Normal. This means that the layer blend mode will have no effect on the original layer beneath. If, however, we change this mode to Screen, the difference will become immediately apparent. The image has been brightened up and the detail that was previously lost in shadow is now visible and we have a much more evenly balanced photo.

If the result is not good enough, we simply duplicate the copy layer using the same method as before. The Screen blend mode is retained so the image becomes brighter still. If this is too intense, we can adjust the effect by lowering the opacity of the layer; this gives us great control over the final image. Once we're happy with the result, the layers can be merged using Layer > Flatten Image.

Fixing overexposure

In contrast to the previous image, this photo has been overexposed and as a result is too bright and washed out. As before, we'll duplicate the background layer, but this time, we'll change its blend mode to Multiply. Doing so will have the opposite effect and make the image darker.

Here's the image with the second layer and Multiply blend mode applied. Again, this quick and simple technique has rescued the photo in a matter of seconds; it's also boosted the colors to give the photo a richer tone. If the effect is too strong, we can always fine-tune it by lowering the opacity slightly.

The Levels command

Every digital image is made up of pixels, and each one of these can be one of 256 levels of brightness: 0 is pure black and 255 is pure white. The Levels dialog gives you complete control over these values, enabling you to enhance your image's exposure, contrast, and color quickly and accurately.

The Levels command is accessed from the Enhance menu under Adjust Lighting. When you open it, you will see the dialog shown in the figure to the right. It may look a little complex, but it is not difficult to get used to. The most prominent part of the window is the histogram. This gives a visual representation of the tones in the image. On the left are the shadows; the middle shows the midtones; and the highlights are on the right. Beneath the graph are three slider controls that let you adjust the separate tonal areas – these are known as the input values. When you adjust them, the tones are shifted across, lightening or darkening the relevant parts of the image.

THE LEVELS DIALOG

1. **The Channels menu:** By default, this is set to composite RGB. Adjustments made in this mode will affect the entire tonal range of the image but not the color.

2. **The histogram:** This displays the tones of the image. If part of the graph goes off the scale at the top, the tones have been clipped and detail in that area of the photo may be lost.

3. **Shadows adjustment:** Dragging this to the right will darken the shadow areas.

4. **Midtone adjustment:** Drag this to the left or right to darken or brighten the midtones. This is generally done once the highlights and shadows have been corrected.

5. **Highlights adjustment:** Dragging this to the left will brighten the highlight areas.

6. **Auto:** Using this tool has the same effect as using the Auto Levels command from the Enhance menu.

7. **Eyedroppers:** The shadow and highlight droppers allow you to define the areas of the image that should be pure black and pure white. The midtone dropper can be used to fix color casts.

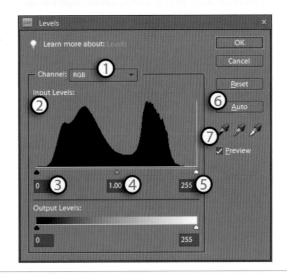

Levels adjustments

1 This image is flat and washed out. Looking at the levels histogram, we can see that it's not overexposed, but there are gaps in the data at either end of the scale. Much of the tonal range is heading towards the midtones. We can boost the contrast here to liven up the highlights and shadows and give the photo some much-needed punch.

 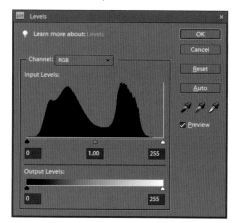

2 We'll begin the correction by boosting the highlights. Click and drag the Highlights slider toward the right edge of the histogram where it slopes down to the base of the graph area, but don't take it too far, as we risk blowing out and clipping the highlights in the clouds and on the lighter parts of the horse. We can already see an improvement, albeit subtle.

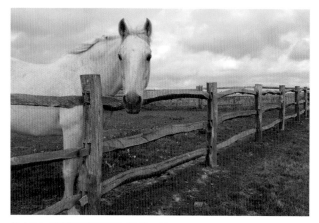 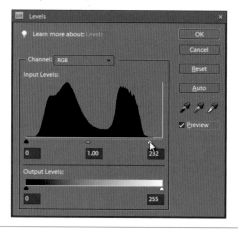

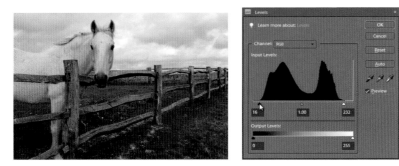

 Now we can do the same for the shadows. Drag the slider across to the right until it meets the bottom of the sloping area on the left of the histogram. This adds richness to the darker areas and really enhances the textures of the fence and defines the clouds and grass.

Although this image works well with just the highlights and shadows corrected, we can adjust the midtones to give it a little more presence. Dragging the midtone slider to the right a fraction adds more contrast. Again, we don't want to overdo the adjustment — we just want to add more punch.

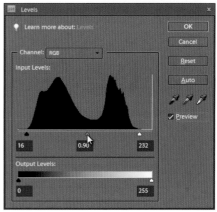

Check to see whether the highlights or shadows are being clipped by holding the Alt key as you drag their respective sliders. Blown highlights show as red/yellow against black, and shadows as red/yellow against white. We can sometimes get away with some clipping if it's not too excessive.

Adjusting highlights and shadows

Although powerful, the Levels command works on the entire image when making corrections. Sometimes you just need to target a specific area that may be too dark or too light. This is often the case on bright sunny days when you have to try and compensate for strong lights and darks; you may find that part of your subject has been lost in shadow. Elements has just the tool for this: the Shadows/Highlights adjustment.

Although it essentially accomplishes the same goal as the Levels adjustment, Highlights/Shadows works in a slightly different way. It analyzes the image and as you make the adjustment, it attempts to create a smooth blend between the dark and light areas so you get a much better result.

This picture was taken with strong sunlight to the left of the subject. The camera has adjusted to compensate for the highlights and as a result, the right hand side has been put into heavy shadow. It would be too tricky to correct this with a Levels adjustment, as brightening the right side would result in the highlights on the left being affected as well.

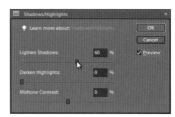

Open the Highlights/Shadows adjustment from the Enhance > Adjust Lighting menu. By default the Lighten Shadows setting is increased by 25%. This has already made a remarkable difference, and it can often be all you need to do to salvage your photo. In this instance, we can push it further still to decrease the shadows: here we've gone up to 60% without any loss of quality.

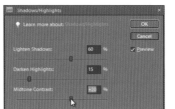

We need to balance out the tones of the image a little. We'll start by adjusting down the highlights on the left side of the boy's face. We need to be more careful here, as applying too much can leave the image looking unrealistic. An adjustment of 15% is effective without being overdone. Finally, we'll increase the midtone contrast and bring back some detail. Again, it should stay subtle: 20%, in this instance.

Color correction

One of the most common color problems is the color cast. This often happens with indoor shots and other forms of artificial lighting, as the light can be warmer or cooler than that of pure daylight. The camera has no way of knowing what should be white, so it makes assumptions based on tones either side of 18% neutral gray. For example, a newspaper is generally white, but under standard house lighting (tungsten), which emits a much warmer light, it will appear more orange. We know through experience that it's still white, but to the camera, it is what it sees and the resulting shot will reflect this.

Most cameras have the facility to alter the white balance to the lighting of the scene; fluorescent lighting, for example, is cool and adds a blue hue to the photo. To counter this, the camera makes the shot artificially warmer. This, however, can also cause problems. If we forget to change the setting before shooting in a different location, the photos may end up being too red or too blue, depending on what the white balance is set to.

This photo was shot at dusk and therefore should have nice warm sunny tones. Unfortunately, the camera's white-balance setting was accidentally left at "tungsten," so the camera has compensated and shifted the tones up into the cooler blues. The photo isn't ruined, but it would certainly look a lot better with its intended colors! Elements has a one-click fix for this: the Remove Color Cast tool.

The tool is found under Enhance > Adjust Color > Remove Color Cast. All we need to do is click on an area of the photo we know should be black, gray, or white and Elements will do the rest. In this case, we've used the side of the main building. If the results aren't what you expected, click Reset and try clicking on another part of the photo.

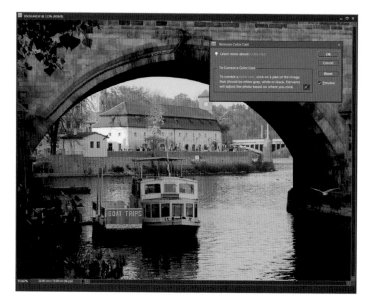

If you get unexpected results from an area that you are sure is neutral, it may be due to the eyedropper tool picking up on a stray colored pixel caused by noise or an unseen blemish. Try moving the cursor across slightly, as this often resolves this problem.

Color variations

There are occasions on which we cannot get rid of a slight color cast or there is something not right with the color that we cannot put our finger on. For this, we have the Color Variations feature. This allows us to increase or decrease the separate reds, greens, and blues in the image in small stages and thus to fine-tune the image to the way we want it.

The dialog is accessed from the Enhance menu under Adjust Color. At the top is a before-and-after view (1); below that are settings to switch between highlights, midtones, shadows, and saturation (2); we then have a slider (3) to control how intense each additional increase or decrease will be. Finally, there is a group of eight thumbnails, each representing the image with the associated adjustment applied: the first six relate to the separate color channels, and the two at the far end are to lighten or darken the image (4).

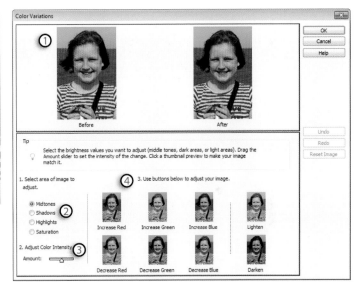

1

We'll start with the midtones, and as it's a fairly subtle color cast, we'll lower the color intensity control by one notch so that we don't overdo the adjustments. The photo seems to have too much green, so we'll begin by clicking the Decrease Green thumbnail once. This has made an improvement, but we now have a slight blue/magenta tint; clicking the Decrease Blue thumbnail once is enough to remove it.

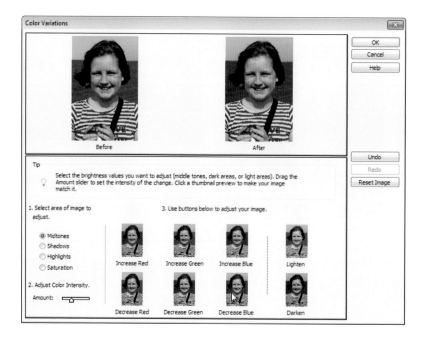

2

Already, after applying these two quick adjustments, we have a more natural-looking photo. We can go a little further, however, and use the Highlights and Shadows adjustments to add a little more color to the subject's skin tone. Selecting each in turn, we'll increase the red by one level in the highlights and shadows. Finally, switching to the Saturation control, we'll increase it by one level to give a richer tone to the picture.

It's tempting to try removing a color cast by increasing the color that appears to be lacking in the image, which in this case is red. This can give poor results, however, as you can end up oversaturating the target color and causing color shifts to the rest of the image.

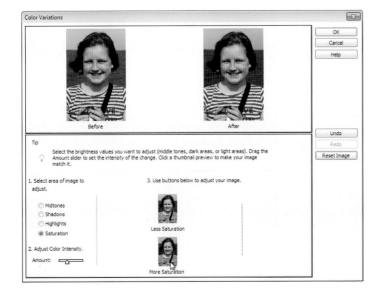

Hue/Saturation

We often have images that appear slightly washed out and lack punch. This can be for many reasons, such as poor lighting conditions on an overcast day, or even that the scene was itself lacking color. We can use the Hue/Saturation feature to both boost the overall color in the scene, or target a particular color range to enhance a more precise area – a pale sky, for example.

1

Snow and rain have a tendency to drain the color from a picture, leaving it washed out and uninteresting. We can quickly restore the lost color using the Adjust Hue/Saturation command, found under the Enhance > Adjust Color menu. We can make this an overall adjustment, as most of the scene is neutral so we don't risk drawing attention away from the subject.

1

We can also isolate colors to adjust; here we'll boost the blue of the sky. First we select Blues from the dialog's color menu. We then click the eyedropper cursor on an area of the sky. It's best to choose a midtone, as this will give a more even adjustment. The sliders at the bottom on the color bars indicate the selected color range. Now when we increase the saturation, only the sky is affected.

We can also use the same technique to adjust distracting colors: the moss on the roof, for example. Select Greens from the color menu. This time when we click the cursor on the desired area, however, it changes to Yellows 2. This is because it's also picking up the tones of the building and spreading across those as well. We can remedy this later, but for now we'll carry on with the adjustment.

This time, rather than adjusting the saturation, we'll alter the hue to blend with the color of the roof. Dragging the Hue slider to the left has the opposite effect of what you might expect, giving the colors a more reddish tone; this is because we're shifting the colors along a logical scale, and because they're already close to the green hues, we are in reality moving them further along toward the reds.

This has left us with a problem: although the green of the moss has been altered, the rest of the building has also been affected. To resolve this, we can adjust the target hues by dragging the range sliders at the bottom of the dialog. By shifting both sliders to the right and keeping the gap between them roughly the same, we can set the correct hue range and restore the color of the building.

Try to keep saturation adjustments fairly subtle. Generally boosting up to around +40 is OK; any more and you may start to see unsightly blocks of color appearing. The lightness slider can also do more harm than good; it's much better to use the Levels command to adjust the contrast.

Black and white adjustment

So far we've focused on getting the colors correct in the photo. Many of us also like to take black and white photos as well, and some cameras have a built-in setting for doing this. The problem with the in-camera method is when you look at it later and realize the shot might have looked better in color, unless you're a whiz at hand-coloring, you're stuck with it! It's much better to take the shot in color with the intent of making it black and white later.

There are several ways of creating black and white images in Elements. The quickest is to use the Enhance > Adjust Color > Remove Color command. This does exactly what it says, of course, and although the results may work well, the resulting images are often left looking a little flat. Black and white photography relies on contrast to make its statement. We could use Levels to adjust the tones but there is a better way. Since

version 5, Elements has had the Convert to Black and White command. This is an all-in-one dialog that can produce fantastic results. It has several presets that can be fine-tuned to achieve the best effect.

As well as making intentional shots look great, you can also use black and white to rescue color shots that didn't come out as well as you thought at the time. Blown-out skies can't always be fixed, but in monochrome there is no issue and they can make a good contrasting backdrop.

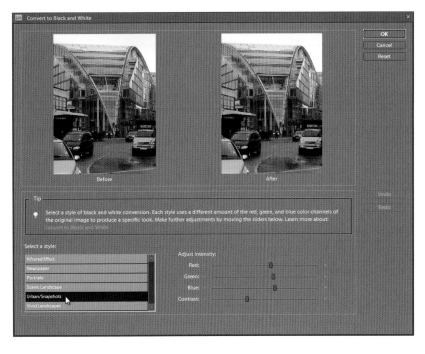

1

Our starting image is a little dreary and what color there is distracts the eye from the building — our focal point. This is a perfect candidate for a black and white scene. We'll open up the Convert to Black and White dialog from the Enhance menu. At the top, we have the before and after views and below are the presets and the fine-tune adjustments; these control the separate color channels and the overall contrast.

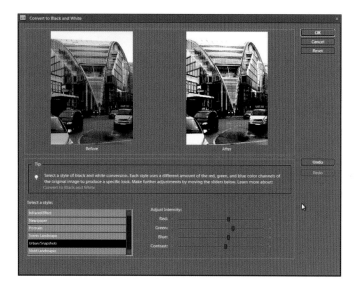

We've selected the Urban/Snapshots preset, which has already produced a really nice result. We can now use the channel and contrast sliders to fine-tune the image. You can make the changes based on the amount of a particular color, but it's often better to experiment until you are happy with the outcome. Here we've gone for a high-contrast, slightly grungy appearance that really brings out the lines of the building.

Adjustment layers

Many of the corrections we've made in this section, such as Levels and Hue/Saturation, can also be applied using adjustment layers. These are called *nondestructive* changes, as they do not directly affect the pixels of the image itself. This makes them highly versatile: you can not only go back and edit the adjustment settings at any time, but can also turn them off, reduce their effect by lowering their opacity, and also change their blend mode, which can completely alter the way they affect the image. The layers come with a mask that can be used to hide areas of the effect, which we'll demonstrate here.

Our example image has suffered from a blown-out sky, which appears almost white. There's not enough color detail to recover so we'll use a gradient adjustment layer instead. This is similar to the gradient filters that you can buy for SLR cameras. We'll begin by choosing a sky blue as our foreground color by clicking the foreground color chip in the toolbox and using the color picker.

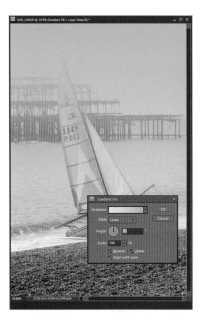

Go to Layer > New Fill Layer > Gradient. Accept the defaults in the first dialog and you'll see the Gradient Fill options dialog. Select the Foreground to Transparent gradient from the pick list by clicking the arrow to the right of the gradient display. Make sure that the Linear style is selected. The blue needs to be at the top, so click the Reverse checkbox. Click OK to set the effect.

The effect is taking shape but needs more work. We can see the adjustment layer in the Layers panel. First set the blend mode to Darken. The color will now affect the image only where the tones are lighter than those of the gradient, so the sky takes the blue but the structure in the background won't. The effect is too harsh, so lower the layer opacity as well; around 40% is good.

The gradient is still affecting the lower part of the image. Pick the Gradient tool from the toolbox. Go to the Options toolbar and choose Black, White from the pick list. Select the Linear gradient icon. Place the cursor at the base of the image then click and drag straight up to the top and release. The black part of the mask hides the gradient and gradually fades out as it reaches the sky area.

This technique obviously relies on having few other objects in the sky area but works well for landscapes and seascapes - it demonstrates how powerful adjustment layers can be. If there are more complex objects in the foreground, you can always paint them out on the mask with the brush tool.

Removing blemishes and other distractions

Up until now, we've been largely concentrating on overall corrections to the tone and color of an image. Generally, this is all we need to do, but there will be times when there is something localized that needs removing, such as the dreaded red eye, a dirt mark on the lens, or a blemish on a subject's skin, to name but a few. In this section of the chapter, we'll look at the many options Elements has for making localized spot edits and other correctional tasks. Many of these are one-click fixes or contained within a single dialog. Others require a little more time and patience, but ultimately you get a better photo.

The Spot Healing Brush tool

For small one-off areas, the Spot Healing Brush is the perfect tool. Here we've zoomed in on the photo and you can see there are a couple of flies that could do with removing. Select the tool from the toolbox and you'll see its options in the Options toolbar. You can choose a brush type and size and set the matching mode. You can also tell it to sample the content of multiple layers.

Using the tool is quick and easy. Simply select it from the toolbox and set the brush size to a fraction more than the object you want to remove; you can do this by choosing one of the presets from the brush picker, or by using the brush size slider. Now all you have to do is click once on the blemish and Elements will remove it and replace the area with a sample from nearby.

1

In awkward areas, it's sometimes necessary to paint with the Spot Healing Brush, rather than using a single click. This works in the same way, but try not to make the area too large, as this can be unpredictable. Larger areas may require the Clone Stamp or the Healing Brush.

You can also change the brush size with the left and right square bracket keys: use [to decrease and] to increase.

Size: 20 px Type: ● Proximity Match ● Create Texture ■ Sample All Layers

The Clone Stamp tool

The pole behind this statue is distracting. We can't use the Spot Healing Brush here because it would try to blend the areas where the two objects meet and would result in a smudged mess. Instead, we can use the Clone Stamp tool. This essentially paints over the affected area with another part of the image that we select beforehand.

1

To choose the source for the tool, hold the Alt key and click a similar area nearby. In this case, the background is a uniform color, so we can pick the section parallel to the pole, and release the mouse to set it. When we place the cursor over the pole and start to paint down, the clear background replaces it and blends in perfectly. We can do the same for the areas lower down.

Fixing red eye

Although most cameras have a setting for avoiding red eye, it's still not 100% effective and one or two photos will slip through with the dreaded demonic stare. All is not lost, of course, as Elements has a great removal tool.

MANUALLY ADJUSTING THE RED-EYE TOOL

There are two fine-tuning options: Pupil Size and Darken Amount. Pupil Size can be adjusted if the tool doesn't fix the entire area and leaves some red, or is too large. Darken Amount can be altered if the pupil becomes too dark or not dark enough.

After selecting the Red-Eye Removal tool from the toolbox the Options toolbar will show the tool's settings. One of these is the Auto button, which is well worth a try. If it doesn't work, however, you can fix the photo manually. Simply click on the affected pupil and after a couple of seconds, the red will be removed.

Noise reduction

Another common issue is image noise. This is common in photos taken using the camera's fully automatic mode, especially when the flash has been disabled in a low-light situation. The camera will compensate by using a slower shutter and raising the ISO speed, making the sensor much more sensitive to light, resulting in a grainy appearance and often containing flecks of random color. The image may also appear soft or slightly blurred due to the longer exposure.

Elements has several ways of tackling noise, ranging from single-click commands to the more involved dialogs. The quality of the results will vary based on how degraded the

original photo is. Sometimes we are able to remove almost all the noise; other times we can reduce the effect only enough to produce a less harsh image.

The Reduce Noise filter is the most powerful of the filters and is accessed from the Filter > Noise menu. The dialog has a large preview window and three control sliders. Strength is the overall intensity of the effect. Preserve Details attempts a compromise between softening the grain and retaining the detail of the image. Reduce Color Noise deals solely with the colored flecks often present in low-light noise. The Remove JPEG Artifact checkbox attempts to reduce the blocking effect sometimes seen when saving lower-quality JPEG images.

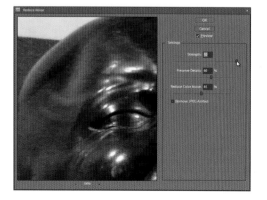

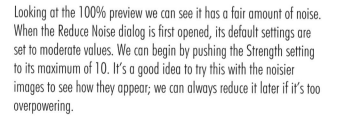

Looking at the 100% preview we can see it has a fair amount of noise. When the Reduce Noise dialog is first opened, its default settings are set to moderate values. We can begin by pushing the Strength setting to its maximum of 10. It's a good idea to try this with the noisier images to see how they appear; we can always reduce it later if it's too overpowering.

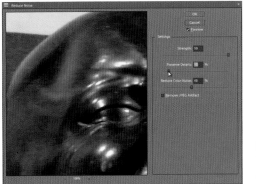

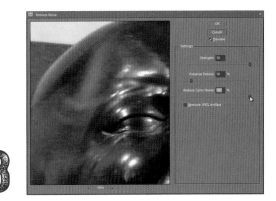

2

Next, we can adjust the Preserve Details setting. Increasing the amount *reduces* the amount by which the noise is reduced. This would generally be used when there is only a small amount of noise but a highly detailed image. Drag the slider to the left and check the results. We've been able to drop it to a low amount but to good effect and without affecting the clarity of the image too much.

3

Finally, adjust the Reduce Color Noise control. Again, we've been able to push this to its extremes on this image. It won't always be the case, however. As with many corrective adjustments in Elements, it's often a matter of trial and error to see how the final image will come out. Overall, this has been successful at cleaning up the photo enough. With the noise lessened, we can attempt to sharpen it up afterwards.

You can view the before and after states in the preview window by clicking and holding the mouse on the image. It's also a good idea to have the main image window zoomed to 100%; you can then toggle the Preview checkbox to see how it affects the final picture.

Sharpening the image

It's a common occurrence that even well-focused images can look slightly soft when viewed close up. There are many reasons for this: it could be the way the camera records the final image or perhaps the quality of the lens – cheaper lenses can produce less than pin-sharp images. Atmospherics play a big part, too; overcast conditions or hot days can affect the clarity of the picture.

Whatever the cause, there are many ways of sharpening up the image to produce a clearer final result and almost all images will benefit from it, especially if they are to be printed, as they can often become softer still as hard copies. When we talk about sharpening an image, we are only making it *appear* sharper, of course, as we cannot bring back lost detail from the original scene or miraculously bring a totally out-of-focus subject into pin-sharp clarity, but it can do a lot for those slightly fuzzy images. One rule you need to stick to, however, is that sharpening an image is the last correction you should make in your workflow, as doing so earlier can cause serious quality issues later down the line.

High Pass sharpening

High Pass is an often-overlooked method of sharpening and offers a very quick and easy way to increase the clarity of your image.

![1]

Although this image looks sharp, when you zoom in to 100%, you can see that it's slightly fuzzy, the flowers aren't crisp, and the features of the butterfly are soft. It doesn't need much enhancement, so the High Pass method is perfect. First create a duplicate of the background layer, because the adjustment we'll be making needs to be made on a copy and blended with the original image.

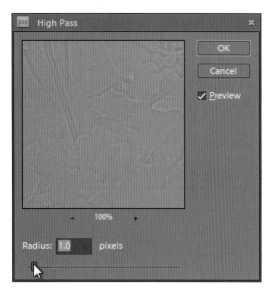

Now open the High Pass filter by going to Filter > Other > High Pass. By default, its value is set to a 10-pixel radius; this is far too high. We need it to be around the 1-pixel mark — sometimes even lower. Click OK. You should now have a gray image with a faint outline of the image, and this is the key to the technique.

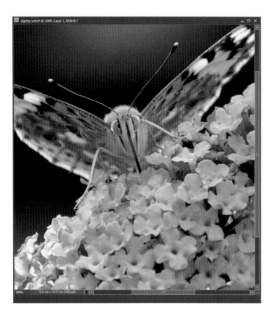

From the Layers panel, set the High Pass layer's blend mode to Hard Light. The background of the layer disappears because the blend mode filters out all the midgray tones, leaving the lighter and darker areas intact. These serve to bring out the detail more and give the impression the image is sharper. It's a little like retracing the outlines of a pen or pencil sketch to enhance them.

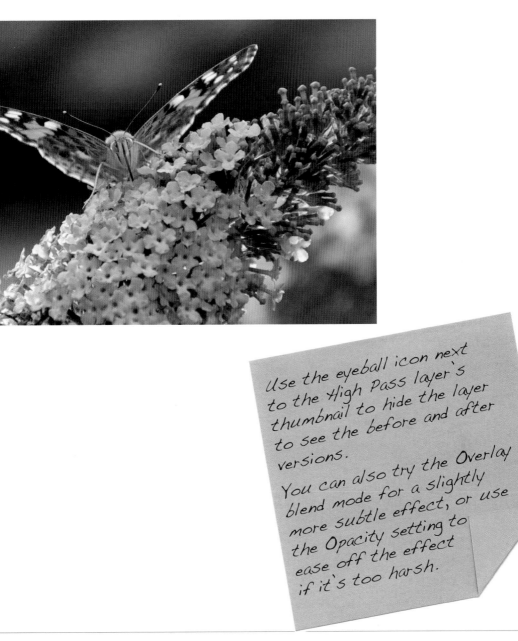

Use the eyeball icon next to the High Pass layer's thumbnail to hide the layer to see the before and after versions.

You can also try the Overlay blend mode for a slightly more subtle effect, or use the Opacity setting to ease off the effect if it's too harsh.

There are, of course, far more intricacies to Elements and the editing process, which far exceed the scope of this book. The examples in this chapter will hopefully have set you on course to getting the most from the images you take, in the least time possible.

Chapter 4: Working with RAW Images

IF YOU ARE lucky enough to own a digital SLR or a high-end compact camera, you will most likely have the ability to capture your images in RAW format. This differs from the usual method of saving images to the memory card: unlike with the JPEG format, there is no processing performed first – the image data is stored exactly as the camera sees it when you press the shutter button.

RAW has two distinct advantages over its JPEG counterpart. First there is no loss of quality between the camera and the computer, which you get in varying degrees with the compressed JPEG format. Although this might not be noticeable to begin with, the quality of preprocessed images can deteriorate slightly when edited. The second benefit to using RAW is any changes made to the image in the postprocessing stage are nondestructive, including color and contrast enhancements as well as straightening and cropping. This is because the changes are not applied directly to the image initially; they are instead stored as a list of instructions in a separate file. After saving changes to the RAW image, you can go back and alter or revert them whenever you like. The only time your alterations will become permanent is when you opt to save the image in a different file format, such as JPEG; even then, the master image is not affected. It's a little like making copies of a photo from a negative; RAW images are often thought of as *digital negatives* and are the basis for Adobe's own unified RAW file standard, the DNG.

Key points in this chapter

How to open your RAW images in the Adobe Camera RAW interface and a tour of its features

Cropping and straightening your photos, correcting the color and tone both automatically and manually

The Adobe Camera RAW interface

Opening images saved in the RAW format is almost the same as opening any other type of image. The difference is that when you choose a RAW image, rather than appearing in the Editor workspace to begin with, it opens in its own window – often referred to as a *modal dialog* – Adobe Camera RAW (or ACR).

To open your RAW image – or images, as you can have several queued up at once – simply

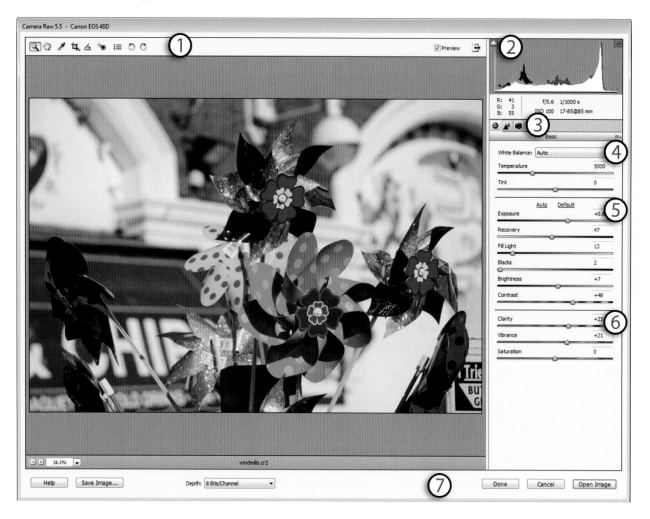

You can also open RAW files from within the Editor itself using File > Open.

highlight it in the Organizer and select Edit > Edit with Photoshop Elements. The Editor workspace will open, if it's not already open, followed by the Adobe Camera RAW window.

You'll probably recognize many of the tools and adjustments in the ACR interface, as they are also found in the Editor. There are also some that are specific to the RAW workflow.

Here's a quick guide to the ACR dialog:

1. **The toolbar:** This houses the Zoom and Pan tools, White Balance, Crop and Straighten, Preferences, and the image rotation tools. You can also enable or disable the adjustment preview and switch from window mode to full screen mode.

2. **The histogram:** A visual representation of the image's tones and colors. This can be used to gauge the correct tonal balance to ensure that the exposure is even.

3. **Panel tabs:** Switch between the Basic, Detail, and Camera Calibration panels.

4. **White balance:** Presets and adjustments to remove color casts from an image.

5. **Tonal control:** This gives you fine-tuning control over the tonal balance of the image. It is especially powerful when used in conjunction with the histogram.

6. **Color control:** You can boost the midtone contrast and color here to add more punch to the image.

7. **Output panel:** This is the final part of the workflow. Here you can save your changes, open the image in the Editor or convert it to Adobe's own DNG format.

Is the image sharp enough?

As with regular image editing, it's good practice to begin the RAW process by confirming that the subject of the image is sharp in all the right areas. It's no good spending time fine-tuning your tonal and color corrections if you then realize that the focus is soft and as a result doesn't look good when the photo is printed.

You can also double-click the Zoom tool icon to display the image at full size.

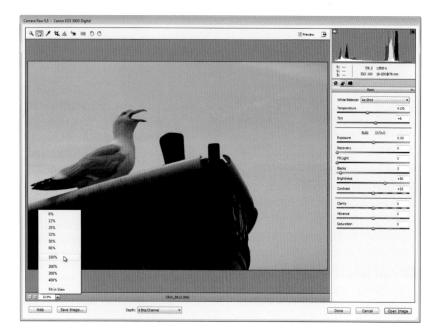

1 When an image is opened, it's automatically scaled to fit the window. Depending on the image's dimensions, this could mean that it's been reduced to as little as 20% or less. This makes it difficult to see if the subject is sharp. At the bottom of the dialog is the Zoom control. You can either click the plus button or select 100% from the pop-up list.

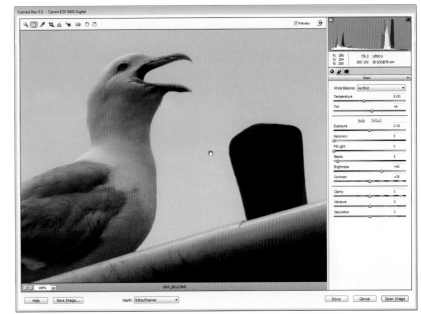

At full size, you can check that the important areas are sharp. Select the Hand tool from the toolbar. Click and drag on the image and pan it around to the subject. You can see that the seagull's features are clearly defined and will look good when the image is printed. To go back to viewing the whole image again, select Fit in View from the pop-up menu, or double-click the Hand tool's icon.

Straightening crooked photos

Crooked horizons, or any other feature that you know should be level, can quickly and easily be corrected using ACR's Straighten tool. By simply dragging the tool across the image following a visual guide, such as the horizon, the software will automatically rotate the image to match. It will also crop the edges to remove any blank space left by the operation.

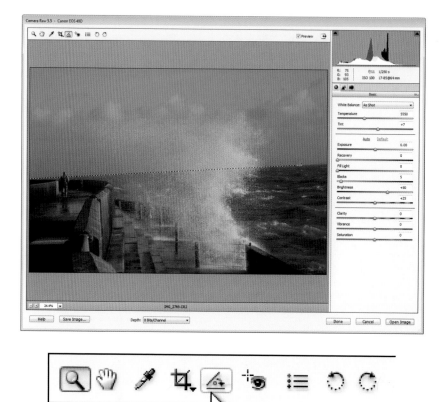

In the example above [or wherever the grab is in relation to the text], we can see the horizon line is far from straight. This can be fixed! Grab the Straighten tool from the toolbar. Position the cursor on the horizon line at the far left of the image. Click and hold the left mouse button. Now drag across, following the horizon line to the far right, and release the mouse button.

2

The software measures the angle and rotates the image to level it out. The bounding box shows how much of the image has to be cropped as part of the process. Double-clicking the image or pressing the Enter key applies the rotation and remove the edges that fall outside the straightened image.

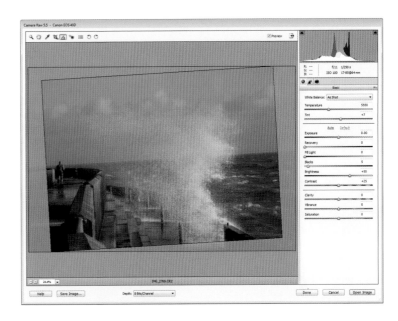

WHAT IF THERE'S NO HORIZON LINE?

If you have an image with no visible horizon line to work from, you can use other parts such as the lines of rooftops or brickwork – as long as the photo was shot head on and not in perspective. You can also use verticals to straighten the image by dragging the tool up or down instead of across the image. It's best to work with guides in the center of the image, as lens distortion can cause lines to be skewed toward the edges of the photo.

Cropping your image

The RAW processor has its own Crop tool, so you can change the aspect to match different photographic sizes or remove areas around your subject that you didn't frame out in the original shot. There are predefined settings for the various different crop ratios or you can make a free-form crop. Being RAW, these changes are, of course, completely adjustable or reversible, as the image is never affected directly.

1

This image was shot horizontally and has a lot of unwanted areas on either side of the subject. Select the Crop tool from the toolbar. Click and drag with the mouse to draw out the bounding box around the area you want to crop down to. When you release the mouse, the parts surrounding the subject will be faded out so that you can see the crop clearer.

2

You can adjust the size of the box by clicking and dragging one of the control handles. You can also reposition it by clicking and dragging anywhere inside the box. Note that if you have specified a preset or custom size, you can scale it only from the corners: it will remain constrained to those dimensions (see the tip box on the following page for more details).

3

Once you're happy with the crop, you can double-click inside the image or press the Enter key to set the changes. The areas outside will be discarded, leaving you with just the selected area. If you want to remove the crop, select Clear Crop from the tool's pop-up. Be aware that this action will also remove any straightening you have applied to the image.

CROPPING FOR PRINT

If you want your image to be cropped to a particular size for prints, click and hold the Crop tool icon. A pop-up will appear and offer you different options. If, for example, you want your photo to fit a 6 × 4 print, choose 3 to 2; a 10 × 8 would be 5 to 7; and so on. You can even define a custom size based on pixels or precise measurements.

When you draw out your bounding box, it will be constrained to the chosen dimensions. You can also change the ratio after you've defined the box and it will be reset to the new size. If you need to adjust the size it will remain constrained until you choose Normal from the pop-up.

Removing red eye

You can remove the dreaded red eye from your photos in the RAW dialog as well. This works in a similar way to the Editor, except, as with all the RAW functions, it remains reversible – just in case you prefer the demonic look later on!

If you find the selection boxes distracting, hide them by unchecking the Show Overlay box in the toolbar.

1

We've zoomed in a little so that the eyes are more visible. Select the Red-Eye tool from the toolbox (or by pressing E on the keyboard). Click and drag the tool's bounding box to surround the pupil and the surrounding area; it actually works better when the selection is large, rather than trying to select just the eye. After analyzing the image, the rectangle will snap to the affected area and remove the red.

2

Sometimes the tool will fail to recognize the area properly and will select only a small portion of the eye. If this happens, you can use the mouse to alter the selection. Hover over the box until the cursor becomes a double-ended arrow. Now click and drag it until it covers the pupil properly. You can also move the box around by clicking in the center of the box and dragging it into position.

Fine-tuning the red-eye removal tool

Although the tool generally does a great job on its own, sometimes there is the need to make small adjustments. For this, there are two additional controls:

- The **Pupil Size** adjustment gives the software a guide as to how wide the pupil is in the image. Use this if you find that the outer edges of the pupil are being missed.

- The **Darken** adjustment controls the opacity of the effect. If the pupil is too dark or too light, it can look fake.

| Pupil Size | 100 | Darken | 50 |

Simple lighting and color correction

As with correcting images in the Editor, there is no right or wrong way to go about adjusting your photos in the RAW workspace; the goal is the same, which is to achieve a nicely balanced picture. In fact, due to its forgiving, nondestructive nature, the order in which you approach the RAW workflow is possibly less important than it is for the conventional editing process.

The example photo, although shot on a bright sunny day, is hazy and washed out. This can be quickly corrected using the RAW processor's features.

1

With RAW images, the white balance information is not recorded at the time of shooting. Clicking on the White Balance drop-down menu gives all the options you would find on the camera. Although we knew the shot was taken on a bright sunny day, we found that the Auto option gave the best starting results. This gave the image a slightly blue temperature and immediately brought out the previously washed-out sky.

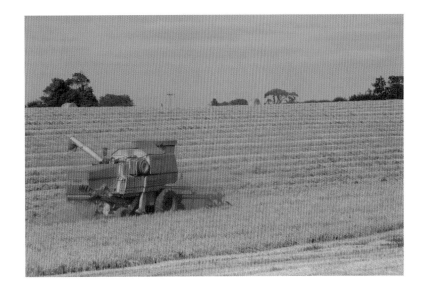

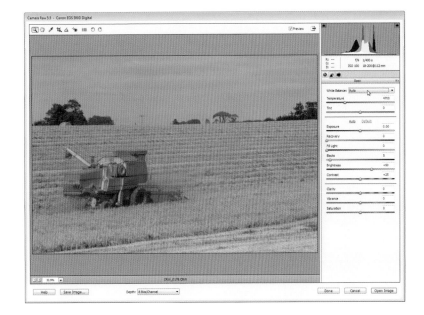

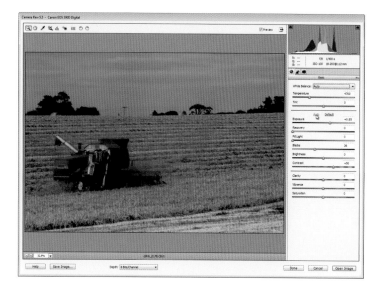

2

The color is a lot better, but the photo still lacks contrast and appears weak and washed out. We could have started adjusting the individual tonal controls; however, a single click of the Auto button did a good job. There's still a little work needed to adjust some problem areas, but it's saved a lot of time overall.

It's always worth trying the Auto options first, if they're available. They don't always work but can save a lot of time when they do!

3

The photo is looking much better now. We weren't happy with the darker areas where the Auto option had cut the brightness to zero and increased the blacks. Lowering the Blacks value slider slightly and adding just a touch to the Brightness brought back some of the detail from the shadows.

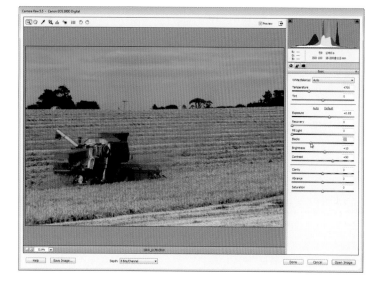

To take it just a little further and add a little more punch to the photo, there are some final options at the bottom of the panel. You're probably already familiar with the Saturation control: there are also two more color correction options, Clarity and Vibrancy. Increasing the Clarity boosts the midtones, and Vibrancy intelligently boosts the less saturated colors. See the tip box on the following page for more details on the correction tools.

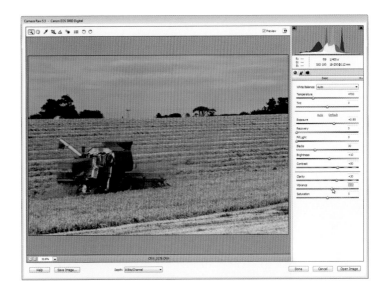

With the image completed, you can save the changes by clicking Done. This updates — or creates, if it's the first time you've edited the image — the XMP file that is associated with the image. This file holds all the information about the photo's cropping, tone, and color. You'll see that the photo's thumbnail has now been updated in the Organizer. No changes were made to the original image, of course.

You can also click Open Image once you have made your corrections. This will open the photo in the Editor workspace. Note that if you make any changes, though, you need to save a copy of the image in a different format (PSD, JPEG, etc.).

If at any time you perform an operation that you want to undo, press Ctrl+Z (press it again to redo the command). If you need to go back several steps, press Ctrl+Alt+Z each time. You can also revert the adjustment sliders to their default states by double-clicking their control handles.

RAW ADJUSTMENTS EXPLAINED

Some of the adjustments will probably be familiar to you, but there are some new additions in the RAW dialog:

- **Recovery** reduces blown (clipped) highlights and can help to bring back some lost detail.

- **Fill Light** is used to lighten the shadows without affecting the darkest areas. It works the same as using a fill-in flash on a bright day. It's great for portraits.

- The **Blacks** adjustment concentrates on the darkest areas to remove shadow clipping.

- **Clarity** concentrates on increasing the midtone contrast, which can help add punch to an image.

- **Vibrance**, unlike its more brutish counterpart Saturation, increases only the areas of color that need boosting. This option is great for making faces more radiant.

Manually adjusting images

Automatic image adjustment works perfectly well in most cases and is generally the first thing to try. You might, however, prefer to adjust your images manually – either to have greater control over the outcome, or because sometimes the software can make mistakes when evaluating an image and not produce the best results. This is where an understanding of the individual image adjustments and the tonal histogram comes in very handy. This may seem a little daunting at first, but as you'll see, it really doesn't take much to get an image looking great.

When you first open an image in Camera RAW, a set of default values is applied. These often don't require changing, but with our example image, this has caused the brighter areas to become blown out, losing a lot of their detail. You can see this effect displayed graphically in the histogram. The right-hand side of the window shows the highlights; the graph extends past the top of the chart, which means that much of the image's highlights are pure white and have lost their detail – in other words, they have been *clipped*.

You can also show the highlights and shadow clipping (where the blacks are too dark) as an overlay on the image itself. Click the triangle in the top-right corner of the histogram window to show the highlights as red, and the triangle in the top-left corner to display the shadows in blue. As you'll see, this really helps when you're making adjustments, because you can watch the hotspots disappear in real time.

Begin by resetting the Brightness value to 0. This has an instant effect on the highlight areas of the man's face; almost all of the red clipping overlay has been removed, and the richness is starting to return to the photo. This is also reflected in the histogram: the highlights (the red areas) have now been evened out, rather than being stacked at the far right.

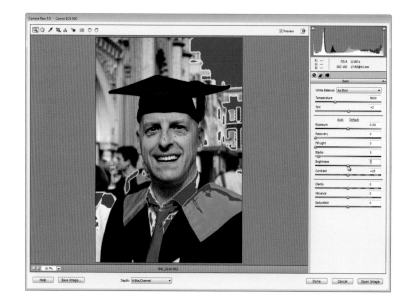

Next, let's make a correction to the exposure. This needs to be adjusted just a small fraction, as the image might otherwise become too dark. As the value is lowered, the clipped areas of the sky and some of the brighter areas of white in the photo begin to disappear. The tones that were still off the top of the scale at the right of the histogram are now well within the boundary.

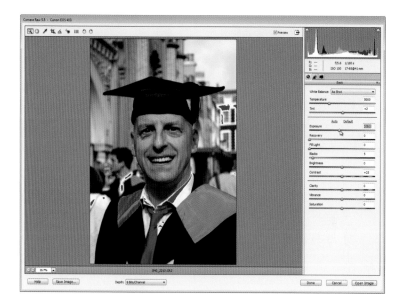

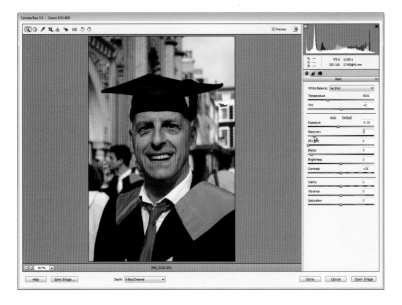

Having corrected the harsher areas, we can concentrate on fine-tuning the image. We'll start with Recovery, which allows us to retrieve some of the lost detail. Pay attention to the histogram as we increase the value and you'll see that the cutoff edge begins to smooth out. We want to achieve a gradual ramp to the far edge with no sudden spiked areas. This will mean that we have a more even tonal range in the highlights.

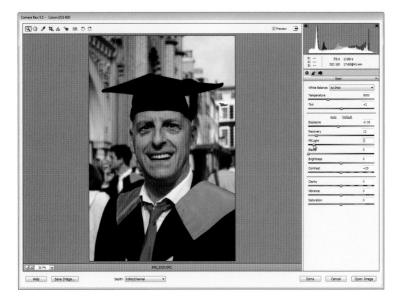

As with the highlights, the blue overlay area shows the clipped shadows. Start by lowering the Blacks slider; this was raised by default. We can drop it to 0 here, which brings the shadows in from the left edge of the histogram. Next, adding a small amount of Fill Light brings out a little more of the detail and softens the tonal cutoff in the histogram.

Be careful: adding too much Fill Light can accentuate noise and also cause harsh areas to appear between contrasting tones, known as banding.

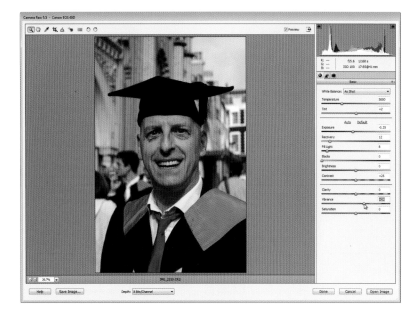

Now that we've corrected the tonality of the photo, we can boost the color, which may have been sacrificed slightly in the previous steps. We no longer need the clipping overlay, so turn it off by clicking the left and right triangles again. We'll add a little punch to the image by increasing the Vibrance. We don't need a lot, and it really finishes the photo off nicely!

You can perform auto adjustments on individual controls by holding Shift and double-clicking its slider.

If you decide that you don't want any of the new settings and want to start again, you can hold the Alt key down and press the Cancel button. This will revert all the image settings to their default values.

Creating a custom camera profile

As you saw in the section on manually editing the tones and colors of an image, ACR automatically applies a default set of values to the photo when it's first opened. This is based on camera profiles that it compares to the EXIF data, which is stored along with the image data in the RAW file.

Although this might be okay in many instances, it can quickly become tedious if you find yourself having to reset them each time you open an image. For this reason, you can create a custom camera profile that will recognize images loaded from your own camera and use the saved settings.

Remember that these new settings will apply to the current camera data only. If you import images from different cameras, they all need to be set up in the same way.

1

To set up a new profile, open an image taken with the camera you want to set the default profile for. Set the tonal and color controls to the desired values. Click the triangle at the end of the panel header and choose Save New Camera Raw Defaults. From now on, each time you open an image taken with this camera, your settings will be used as the defaults.

Processing multiple images

Another great feature of the ACR processor is its ability to perform corrections on multiple images simultaneously; this applies to almost any adjustment you can make on a single image, including straightening and cropping. Being able to work in this way is of particular use if you have several shots taken in similar conditions.

Choose the images you want to edit in the Organizer. You can do this by holding the Ctrl key while clicking the thumbnails, or by clicking and dragging a selection box across the range of photos. Go to Edit > Edit with Photoshop Elements to open them in the ACR window.

Once the ACR dialog has opened, you'll see the images in a column on the left side of the window. You can select all by clicking the Select All button at the top or a set of them by Ctrl-clicking the thumbnails. You also have the option to rate them with the star system; if you then hold the Alt key and click the Select All button, it will select just the rated images.

With all four images selected, any operation we perform will be applied to the whole group simultaneously. Here, for instance, we've run an auto-fix to remove the overexposure and applied some Fill Light to enhance the detail in the darker areas. You can see the warning triangles on the thumbnails as they are being updated. As with the single image, you can opt to close and save the changes or open them all in the Editor.

Notice how all the values are blank, apart from the manually adjusted Fill Light setting. If you select one of the images and compare it with the others, you'll see that it's not a blanket adjustment; each one has been assessed and corrected on an individual basis.

Saving your changes

Once you're happy with your changes, you should save them. You have several options here, all of which are located on the bottom bar of the ACR dialog.

Save image. Despite its familiar title, this doesn't save the file in the way you would expect it to. Choosing this option lets you convert the standard RAW file to Adobe's own DNG format, which has some distinct advantages:

• *Lossless compression:* The image data is compressed without losing any detail, so the file size can be considerably smaller than its RAW counterpart.

• *Embedded previews:* An image preview can be saved with the file to allow greater compatibility with third-party software. Note: doing so increases the file size.

• *Integrated image data:* Standard RAW photos store all their image information in a separate XMP "sidecar" file. If this is deleted or becomes detached, all the details about adjustments, keywords, and so on will be lost. With the DNG format, this information is held within the main file, which makes it totally portable.

• *Compatibility:* Although RAW is a common format, the way these files are constructed varies between cameras: Nikon's NEF is different from Canon's CR2, and so on. Adobe is trying to standardize the format, so when you dig out all those old files in years to come, your computer will still be able to read them.

You don't have to have an Adobe product such as Elements or Photoshop to read DNGs, either. A free converter is available from Adobe's website for both the Windows and Mac platforms.

Depth. This has two choices, 8 bits/channel or 16 bits/channel. Without going into the complexities of the subject, in simple terms, this is how much color and tonal information is in the image; the latter is capable of holding more and will have much smoother graduations between different colors and contrasts.

Note that if you save your images as 16 bit, some of the filters and functions in the Editor will be unavailable.

Done. This simply updates the XMP file with the changes you have made and closes the window. When you return to the Organizer, the thumbnail will be updated.

Cancel. This abandons any changes you have made and closes the window.

Open image. This opens the image, with any adjustments you've made, in the Editor. It's the final stage in your workflow, in which you can make changes to the image: removing unwanted objects with the Clone tool, adding adjustment layers, running filters, and so on. Bear in mind that this is still technically a RAW file, so the edits you perform cannot be saved directly. You must save in a different format such as a JPEG or a Photoshop PSD file.

Chapter 5: Printing, Sharing, and Storing

WHETHER IT'S TO document a particular event or occasion, or as an artistic pursuit, photography is and always has been the medium to instantly and faithfully capture a permanent record of what's happening around you. Although some pictures might be only for a personal collection, more often than not you will want to share your photos with your friends, family, or even the whole world. Traditional photography has just the one method of doing this – the processes of development and printing. With digital photography, however, there are numerous ways to get your pictures seen.

Elements has many great options for presenting your photos. You can print them, of course, either as individual pictures or by using a variety of different creative design ideas and templates. These can be output from your own printer or via an online printing service to produce stunning photo books, calendars, and other gift and presentation ideas. You can also email your photos to your friends and family, produce self-contained albums with animated slideshows, and create web pages and interactive CDs or DVDs.

Key points of this chapter

Understanding color management, and how to get the best from your prints

Printing through Elements, both from your own printer and via online printing services

Sharing your photos with people using the built-in creative tools

Creating backups of your photos to avoid losing them, should something happen to your computer

With all these virtual images now possible, it's all too easy to become complacent and to not think about protecting them against possible disasters, as you might have done with the physical slides, prints, and negatives from your film cameras. Many different things could spell disaster for your photos. This might be a hard disk failure in your computer, or you might accidentally delete or overwrite your catalog. Fortunately, Elements can back up your images to another area on the computer or to an external hard disk, or to a CD or DVD, ensuring that your precious photos are as safe as possible.

Color management for printing

When you take a photo, the camera captures the scene and its colors as accurately as possible. When it comes to printing your images, certain factors can cause a photo's color

and tone to look different to how it appears on the screen.

Although it's beyond the scope of this book to delve into explaining the vast intricacies of the color matching process, in this section we'll look at ways to help ensure that you get the best reproduction from the camera to prints with the minimum amount of fuss.

Color spaces

Color spaces describe the spectrum of color shades portrayed through red, green, and blue and the hues between, which are based around pure white. Cameras, printers, and monitors are capable of recording or outputting only a small portion of this space, known as the *color gamut*. Colors that fall outside of this are termed as being *out of gamut* and are either substituted for the nearest in-gamut shade or removed by the device. Problems can arise when a photo is in one color space but the output device is

in another, in which case the translation of color can cause the image to show odd results. It's a little like asking someone to give you a number between 1 and 20, but he or she chooses 35. By matching color spaces among the photo, Elements, and the printer, you have a far better chance of getting a faithful reproduction in print.

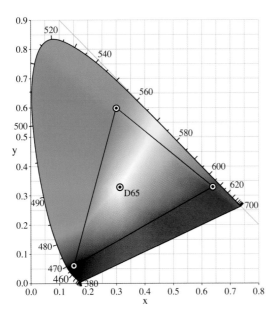
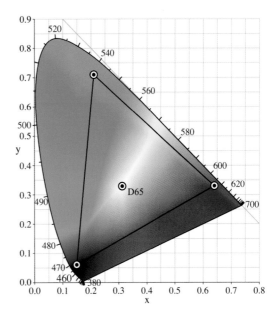

In digital photography, there are two widely used color spaces, sRGB, the image on the left, and Adobe RGB, on the right. The area within the triangles represents the color range available. As you can see, Adobe RGB has a much wider range of colors compared to that of sRGB. Many cameras have the option to choose between the two spaces; it's worth switching to Adobe RGB if you can, as the captured image will hold much more color information to begin with.

The color-managed printing workflow

Now that you've learned the concepts behind color management, we can go on to look at the workflow for printing in Elements. Although this potentially complex process has been made as straightforward as possible, there are still a few important steps to be considered. We'll begin by making sure the color management workspace is set up correctly, then go on to explore the standard print dialog and set up the printer's own corresponding color settings.

Photos can be printed from either the Organizer or the Editor, although there are more options available in the Editor's version, so this is the dialog we will be focusing on to demonstrate the color setup process.

The first thing to do is set the color
management environment in Elements.
Go to Edit > Color Settings and make
sure that Always Optimize for Printing is
selected. Click OK to accept the choice. You
may not notice any change to the photo
itself, but when printed, this setting will
give the most accurate transition from
screen to paper.

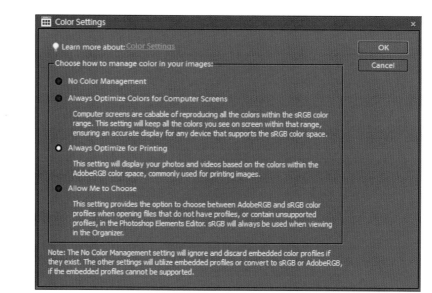

Next, we'll set up the printing preferences.
After opening an image in the Editor, select
File > Print to display the print dialog. If
you have more than one printer available,
check that the correct one is selected from
the menu.

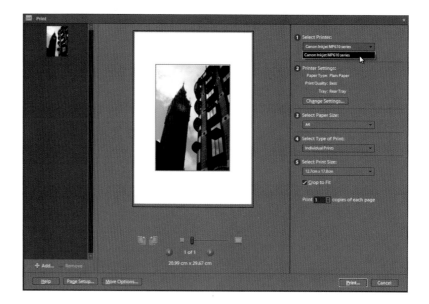

The next thing to do is set up the color management on the printer. Click More Options and select the Color Management tab. Under Color Handling, choose Photoshop Elements Manages Colors. If we don't set this, the translation of colors from the screen to the printer could be wrong, producing inaccurate results.

In some versions of Elements, the color handling options are on the main part of the print dialog.

Some printer profiles have the paper type as a subset on the main menu; others use the printer's own preferences dialog to set this.

Click the Printer Profile drop-down menu. Many printers come with their own color profiles, which not only helps to translate the color information, but also takes into account the paper type you are printing to, as this has a big impact on the way the color is portrayed. If there is no profile available for your printer, choose Adobe RGB instead, because this is the color space that Elements is set to.

5

Printer software often has built-in color enhancement features. These are great for printing from software that does not use its own color management, but can cause problems when printing from Elements. Choose Printer Preferences from the dialog. In our example, color adjustment is accessed from the Main tab under Color/Intensity. The matching option has been set to None. Refer to your printer's manual to find out how to do this on your own printer.

The final setting is Rendering Intent. This setting determines how to deal with out-of-gamut colors. Generally Relative Colorimetric would be the option to choose, as this keeps the colors as faithful as possible, but at the cost of sacrificing some color saturation. If you want to maintain the powerful colors in the photo, choose Perceptual, which keeps the depth of color at the cost of slight hue changes.

Although it's possible to set up the paper size and quality of the print using Elements' own dialogs, it's often better to use the native printer dialog, because all the options are in one place, including some printer-specific settings, such as the controls for borderless printing. To do this, select Change Settings > Advanced Options; again, the name and location of this may vary, depending on your version of Elements.

Printing multiple photos, picture packages, and contact sheets

With Elements, you're not limited to printing a single image on a page. You can select several different photos to print sequentially, either as single sheets or several on the same page. You can just as easily have different versions of the same image: one full size and others in a range of different sizes.

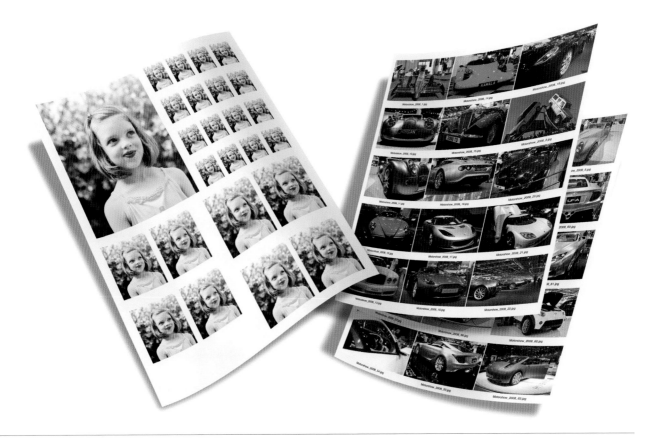

Printing multiple images

The quickest way to select photos to add to the contact sheet is with the Organizer. You can select as many as you want, and you can, of course, select them all, either by choosing Edit > Select All or by having no images selected at all; naturally, you'll want to be careful with this if you have hundreds or thousands of images in your catalog. Fortunately, Elements warns you before adding them.

You can open or switch to the Organizer from within the Editor at any time by clicking the Organizer button at the top right of the workspace.

You can also add or remove images from the print dialog with the + and − buttons at the bottom of the image list window.

Open the print dialog by selecting File > Print. The selected images appear in the left side of the window. The default setting is for two images per page (when using letter-size paper). Depending on how many images were selected, Elements will generate the required amount of pages. You can flip through these with the arrows at the bottom of the dialog.

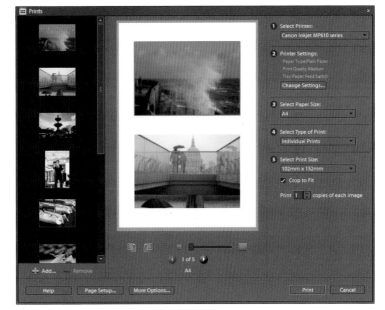

If you use custom-sized photo paper, you can change the paper size accordingly, such as 5 × 7".
Elements will print each out in turn onto a single sheet. Make sure to choose the correct print size in
order to fill the paper; the options in the Print Size menu will change to reflect the current paper size.
If your printer has a borderless capability, you can set this within the printer's own software dialog.

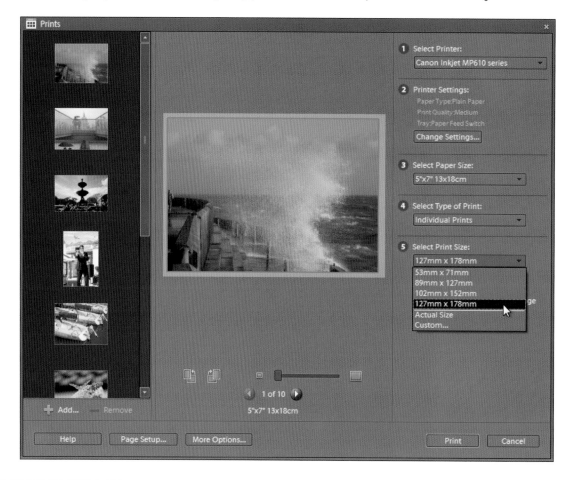

Creating picture packages

As well as printing a page full of different images, you can also print a variety of sizes of the same photo.

1

With a single image selected, open the print dialog. Select Picture Package from the Select Type of Print menu. You'll still only see one photo on the page. Now check Fill Page With First Photo. This will add another copy of the photo next to the original. This is the most basic type of picture package. This setting is a good choice if you want to make several large copies but don't have precut paper.

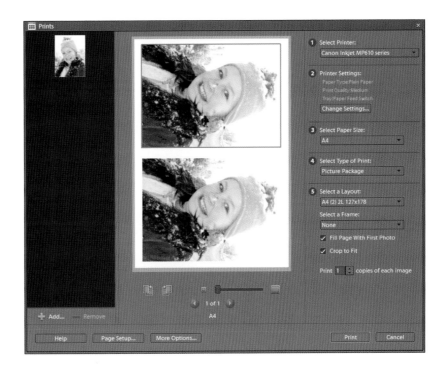

2

If you want to be a little more adventurous, select one of the many available presets. Here we've gone for a layout that gives us several different sizes of the same image. This is great for creating prints for different types of gifts, such as wallet photos and even keychains that you can add your own pictures to.

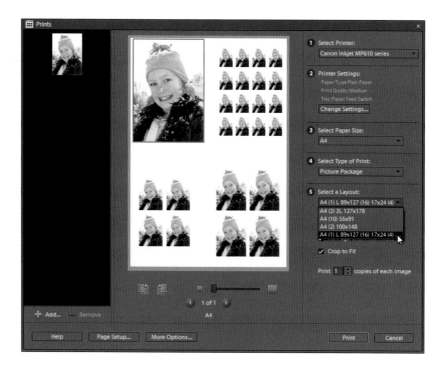

Different paper sizes give you alternative layouts. Some are restrictive and you may lose part of the picture. Elements will warn you of this.

Creating a contact sheet

If you have taken a lot of photos at a particular event – a wedding, for instance – not everyone might want a copy of them all. Fortunately, you can print a contact sheet showing the thumbnails and information for a whole batch of images, allowing people to point out the photos they'd like. You choose the layout and Elements will do the rest, scaling and rotating to best fit the page.

1

Select the relevant images and open the print dialog. Click the menu next to Select Type of Print and choose Contact Sheet. The display will change to display a page of the chosen images; in the figure below, there were 80 images selected, so the current five-column display gives us twenty to a sheet and four pages.

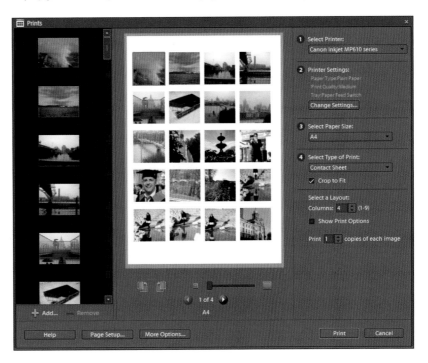

Currently, the images have been cropped to fit square thumbnails. This is a good way of setting them out and looks tidy, but you have no way of telling whether the images are landscape or portrait. If you uncheck Crop to Fit, the whole image will be displayed. If the thumbnails are too small, reduce the number of columns in the layout options. Remember: this will increase the number of pages to print!

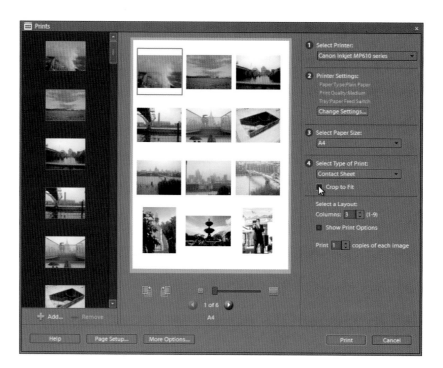

You can also display information about each image. Click Show Print Options. You have the choice of showing the date the photo was taken, the image caption, the filename, and page numbers on the sheets. If you're planning to use the contact sheet to show people so that they can pick individual images to have copies made, you should definitely print the filenames — it will save a lot of time in the long run!

Image data takes up additional space, which could reduce the number of images per page.

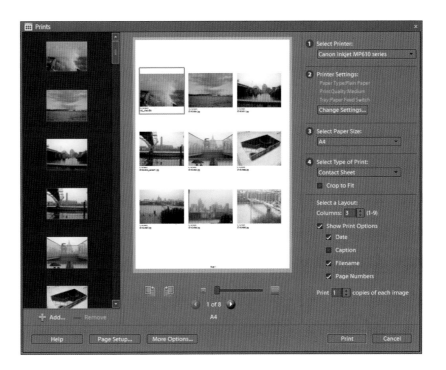

Using online print services

Although printing using your own printer is the most convenient way of getting hard copies of your photos, it's not always the quickest or cheapest solution, especially if you have a lot of images or want to make several copies for friends and family.

There are many online printing companies to choose from, including two that you can use directly from Elements: Shutterfly and Kodak, which makes the process almost seamless. Select the photos you want to print in the Organizer and with a few clicks of the mouse, they are submitted and ready to order for delivery straight to you.

If you prefer, you can go directly to the website, where you can have your photos printed on posters, canvases, and novelty gifts such as mugs, bags, and cushions. You can't do that at home!

It's worth noting that most online services ignore the embedded color profiles in image files and use sRGB. If you're planning to print your photos online, select Always Optimize Colors for Computer Screens in the Color Settings dialog. This ensures that you get a good representation of how they will look.

Backing up your photos

Picture the scene: you come home, switch the computer on, and it tries to boot up but fails, telling you there might be a hard disk problem. You call a repairman, who confirms the worst: the hard disk has indeed failed and he cannot recover the data. This was the place where all your photos were stored, and now they are gone for good!

This might sound like something that always happens to somebody else, but it's more common than you might think. With a little advance planning, however, you can avoid losing your data by making regular backups. Almost every computer has a CD writer, and with huge external hard disks relatively cheap now, there's no reason to avoid investing a little time and expense into protecting your digital memories.

Elements has its own built-in backup system; you may have seen the dialog pop up every now and again telling you that you should be considering a backup – the one that we always dismiss until a more convenient time! In this section, we'll look at setting up a backup using the built-in option, as well as a couple of other methods.

1

You'll no doubt be familiar with this dialog, with its enticing Remind Me Next Time button, not to mention the Don't Show Again option. Click the Backup Catalog button. If you did dismiss the reminder for good, however, you can still start the backup process by choosing File > Backup Catalog to CD, DVD or Hard Drive.

2

The first dialog box gives you the choice of how to back up your files. There's a full backup option and an incremental option. If this is the first backup, you need to keep the Full Backup choice highlighted, as it creates a complete mirror of your current files. Once this has been done, you will be able to select the faster incremental option, which adds only files that have changed since the last backup.

3

The next stage is to choose the location for your backup. Although it's possible to back up to CD or DVD, this is only recommended for smaller catalogs, because you could end up going through a lot of discs – not to mention the time it takes to write the files. Using an external hard disk is a much better option; it has far more storage capacity and is much faster to back up to.

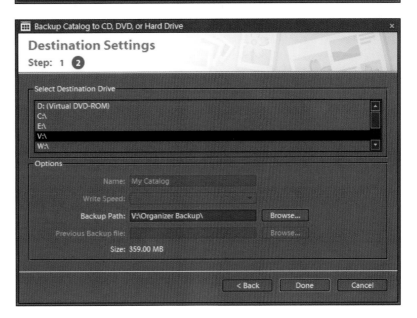

Any external drives that you have connected to the computer will be listed, along with any internal storage options, in the destination choice dialog.

After choosing or creating a folder for saving the backed-up files on the drive, click Done. A progress window will appear. This process can take a few minutes, depending on the number of files. You can choose to stop the process by clicking Cancel at any time. A confirmation dialog box will pop up once the process is finished to let you know it was successful.

Adding to the backup

1

Once you have created the initial backup, you'll want to periodically add new files. You can either wait for Elements to prompt you, or start the process manually (File > Backup Catalog to CD, DVD or Hard Drive) as before. You probably won't want to copy every file again, so this time, choose Incremental Backup. Click Next to move on to the next part of the process.

2

The first thing you need to do is specify a new location, as you cannot overwrite the previous backup, as it needs this to refer to. Here, we've created a subfolder within the original backup folder and named it Inc to specify that it's an incremental backup, followed by the current date, which will make it clearer later, should you need to restore.

Now specify the previous backup location and point it to the backup file. This allows Elements to determine the difference between the previous backup and the current catalog, so it knows exactly what to copy and what to ignore, if nothing has changed since the last time. Click Done to start the process. Repeat this process on a regular basis to ensure that your changes and additions are kept safe.

Name	Date modified	Type	Size
Inc 06012010	01/06/2010 21:06	File folder	
Backup.tly	01/06/2010 20:35	TLY File	102 KB

Locate Last Backup

Computer ▶ SILO on '.psf' (V:) ▶ Organizer Backup ▶

Search Organizer Backup

Organize ▾ New folder

Documents
Music
Pictures
Videos

Homegroup

Computer
Local Disk (C:)
DVD RW Drive (D
SILO on '.psf' (V:)
Juggernaut on '.p

File name: Backup.tly Tally (*.tly)

Open Cancel

Restoring from backup

1

Should the worst happen and you lose all your images, you now have the backup(s) to fall back on. Select File > Restore Catalog from CD, DVD, or Hard Drive. The restore dialog will appear. The first section asks you where to restore from. In this case, choose Hard drive/Other Volume. If you have made incremental backups, make sure to choose the *most recent* version — otherwise, you will not restore everything.

Restore Catalog from CD, DVD, or Hard Drive

Restore From
- CD/DVD
 - Select Drive: (D:\)
- Hard drive / Other Volume
 - Locate the Backup File: V:\Organizer Backup\Backup.tly Browse...

Restore Files and Catalog to
- Original Location
- New Location
 - Specify Destination: <NONE> Browse...
 - Restore Original Folder Structure

Restore Cancel

2

Now specify a location for saving the restored files. This will generally be the original location. Click Restore. A warning will appear advising that this may alter the file structure. This could be the case if you have changed the version of the operating system or specified a custom location for the previous catalog. You could at this point click No and go back to specify another destination. But this time, click Yes to continue.

Elements Organizer

You have selected Original Location option as your restore location. With this option, restoring to a computer which is different from the one you had backed up might create some changes to your existing file structure. New folders might be created or new files added to existing folders.

Do you want to continue?

Don't Show Again

Yes No

3

If this is an incremental backup, you will receive a warning to tell you that you must have access to every instance. Click Yes to continue. The files from the latest incremental backup will be restored first; you'll be prompted to locate the others, and finally the original master backup. These will be restored in turn. Once completed, the images will reappear in the Organizer.

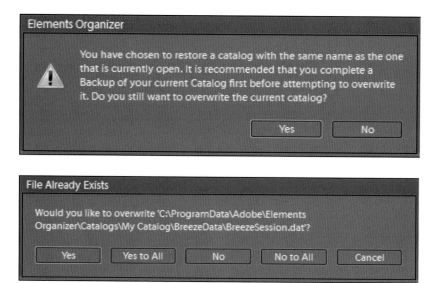

RESTORING DELETED FILES

If you're restoring a catalog from which the images were deleted by mistake, rather than lost due to technical failure, you may be asked to back up the current catalog and confirm overwriting the system files Elements uses to keep track of the files. You can usually continue if it's the entire catalog, but you may want to select a new location if only a partial restore is needed, just to be safe. You can always copy the files between catalogs to keep it tidy.

Alternate backup solutions

We've looked only at locally attached devices as a means of storage for backup files. As the speed of the Internet increases, facility for online storage has become more commonplace. Adobe have Photoshop.com, an online gallery and storage area where you can upload and synchronize your images (synchronization is currently available only in the United States) directly from recent versions of Elements. There are also online galleries such as Flickr.com and Google's Picassa

that offer very affordable rates for almost infinite storage; these are limited to the common web-based image formats, however, so RAW, .psd, .tiff, and the like cannot be uploaded. For more versatile storage, Dropbox.com offers a superb solution that can automatically synchronize your images (and other files, of course) between multiple computers. All these sites have the benefit of being backed up continuously, giving you absolute piece of mind.

Some final technical information

One of the major causes of discrepancies in color and tone between the onscreen image and printed images is a poorly calibrated monitor. The physical settings of the monitor can have a dramatic effect on how the finished print differs to its screen equivalent. Brightness and contrast determine how highlights and shadows are displayed; what may look good on screen may appear too light or dark on paper.

The most accurate way to calibrate your screen is with a hardware device, such as Pantone's Huey, that measures the color and contrast on the screen and creates its own custom color profile based on the results. They're not cheap, however, so you need to decide whether you can justify the expenditure.

A quick and effective way to get your contrast set up correctly is to use an onscreen monitor calibration chart, similar to the one shown here:

The left and right far ends of the scale represent the absolute black and white points, respectively. By adjusting the brightness and contrast of the monitor, the tones in between can be balanced out to produce an even graduation from black to white in which the individual blocks are visually discernable from their neighbors. Here we see how the chart might look if the monitor is too light or too dark:

Looking at the top scale shows that the display is too bright – there's very little difference between the top few blocks at the white end of the scale. Conversely, the bottom scale shows the screen is too dark and the grays at the black end blend into one. A more detailed version that allows for better fine-tuning can be found at http://www. photofriday.com/calibrate. php.

Many LCD monitors and laptops come with their own preset profile on CD, or one that can be downloaded from the manufacturer's website. This is usually available through the display settings of your operating system.

We do hope you have enjoyed this book and that you have picked up some useful information to enable you speed through your digital photography workflow with Photoshop Elements and get back out there capturing all those precious moments. Happy shooting!

Index